PHOTOGRAPHING
DOGS

TECHNIQUES FOR PROFESSIONAL DIGITAL PHOTOGRAPHERS

LARA BLAIR

AMHERST MEDIA, INC. ■ BUFFALO, NY

Check out Amherst Media's blogs at: http://portrait-photographer.blogspot.com/
http://weddingphotographer-amherstmedia.blogspot.com/

Published by:
Amherst Media, Inc.
P.O. Box 586
Buffalo, N.Y. 14226
Fax: 716-874-4508
www.AmherstMedia.com

Publisher: Craig Alesse
Senior Editor/Production Manager: Michelle Perkins
Assistant Editor: Barbara A. Lynch-Johnt
Editorial assistance provided by Sally Jarzab, John S. Loder, and Carey A. Miller.

ISBN-13: 978-1-60895-540-4
Library of Congress Control Number: 2012936515
Printed in the United States of America.
10 9 8 7 6 5 4 3 2 1

Contents

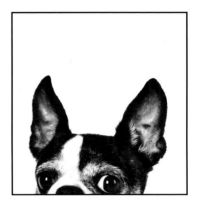

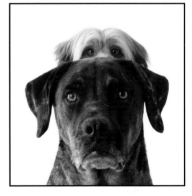

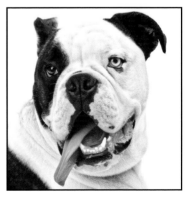

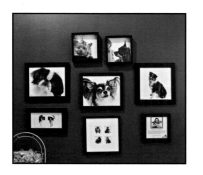

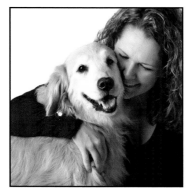

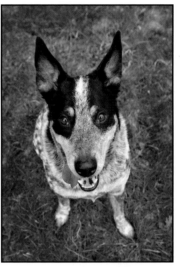

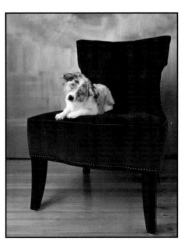

Dedication

I'd like to thank my husband, Dave, who has always supported my ever-changing career as a photographer over the years. From working weekends to deciding not to work weekends, from taking multiple clients over the holidays to scaling back for the sake of our family, from capturing everyone under the sun to finally finding my way to the dog world, you have always believed that I could find the perfect path in this industry. I love you forever and ever.

To my sweet daughters, Katie and Rachel, I express deep gratitude for your enthusiasm about my work. You see the beauty in these animals as much as I do, and it is always fun to share it with you. Thank you, also, for being my muses over the years. As difficult as it was, the posing that you've done for me in costumes, in the forest, and in the rain have been my favorites. You are my proudest accomplishment. I love you.

For Kate, caretaker of the animals who needed it most, I say thank you for the gift of Fauna. You were a blessing in my life and I miss you. Having your little dog in our lives reminds us to always be kind, caring, and loving with all living creatures.

About the Author

Lara Blair began her photography business in 2000 with a film camera and a dream of creating black & white photographic art for families. Over the years, she incorporated color film and eventually did a complete transition to digital, with a learning curve that amazed her. A move to New York with her family inspired her to fine-tune her style and type of subject she preferred to capture. It is there that she discovered she was more interested in what the family dogs were doing while taking family portraits. A move back to Washington state was the perfect time to re-invent the wheel, and Lara Blair Images dog studio was born!

Lara has a passion for working with women who are beginning their journey with photography. With a master's in teaching, she uses all of her skills to instruct the technical part of this art, but also facilitates the artistic quest for individual style and subject matter. Her annual retreat, "Ignite the Heart," alternates between Italy and the Oregon Coast and takes only twelve people. This is the highlight of her year. Lara also teaches workshops in her studio and around the country.

Lara loves to create collages and large wall displays using digital imagery and other mediums. She is a lover of the vintage world and enjoys taking dreamy images of styled subjects which are displayed on her personal blog, Modernprairiegirl.com.

For more information on classes and retreats, please contact Lara at lara@larablairimages.com or visit larablair.com.

Author photo courtesy of David Blair.

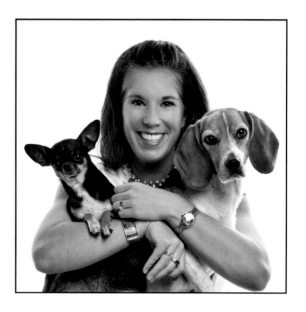

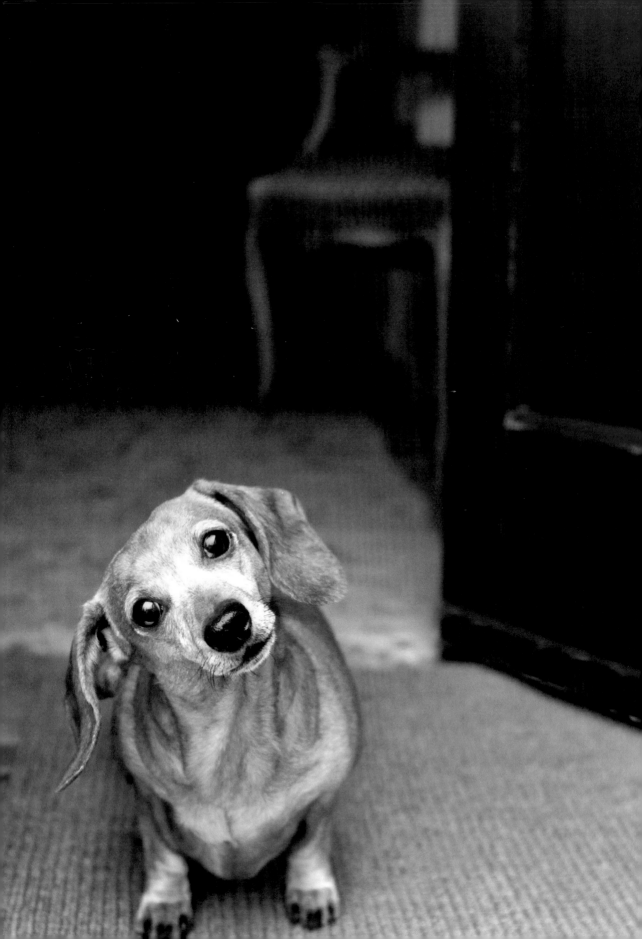

Introduction

Dogs are not our whole life, but they make our lives whole.—*Roger Caras*

In this digital age of photography, there are people opening their portrait studio doors every day. It seems that in any given town there is a plethora of photographers for potential clients to choose from, and at times it can be difficult to differentiate them in terms of their photographic style and level of experience. I had always believed that finding a niche market and focusing on this client base alone would be the key to creative and financial success in the portrait photography industry. Not only is it a lot less complicated to market to and provide excellent service for a niche market, it is always a good thing to be seen as an expert in one particular area of photography. Potential clients who belong to this niche will seek you out and hire you because they trust that you are the best.

For me, it proved to be true. I just never thought it would come in the form of a four-legged creature that slobbers on my backdrop. Now that I'm in the middle of this treat-giving/ear-scratching/ball-throwing portrait world, I can honestly say that it's the best decision I ever made. I had been, like so many boutique

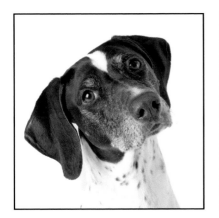 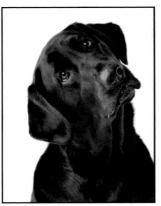 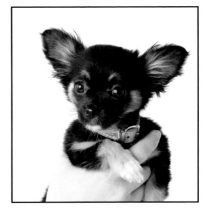

Facing page—Welcome to the world of dogs. Come in, come in! **Left**—Dogs are like people with their expressions in so many ways! It is a pleasure to capture them. **Center**—A lab's expressive eyes get me every time. **Right**—The smallest of creatures can make a day in the studio a special day.

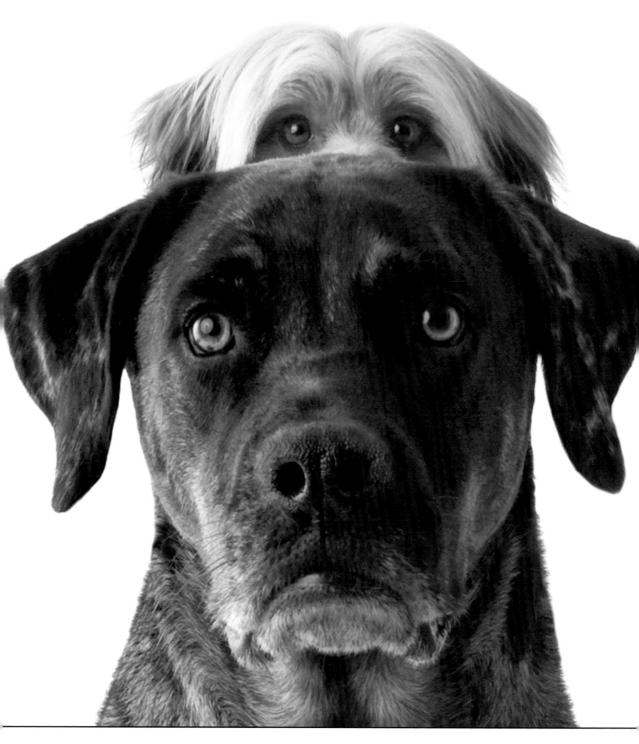

My life and work went to the dogs—and I couldn't be happier!

studio owners out there, a "Jill of all trades," photographing just about anyone who wanted to schedule a session. I found that there were certain client ages that were difficult to work with (goodness knows, my own kids in their toddler years were a portrait nightmare!) and there were sessions I had trouble ending because my subject matter was just so darn fun. Enter the dog friends and their owners. I loved these sessions more than any other, and I began to notice that I was capturing them for art's sake outside of studio hours. I also had success working with

a Humane Society as our main charity project. This was the key to a full-on revamping of the studio marketing campaign and a much happier, more balanced work life that brings me joy every day.

If you're a dog lover, this niche market might be the perfect way to go in reshaping your business—you will just need the tools to get you there. I will share all that I have learned (mistakes made too) to help you create a dog portrait studio that stands out, wherever you do business.

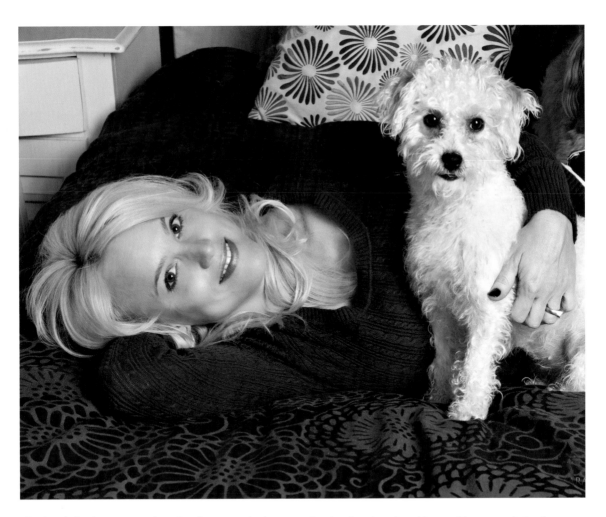

The family bed is a great place for dog portraits because the dog is relaxed and happy (the owner is too!).

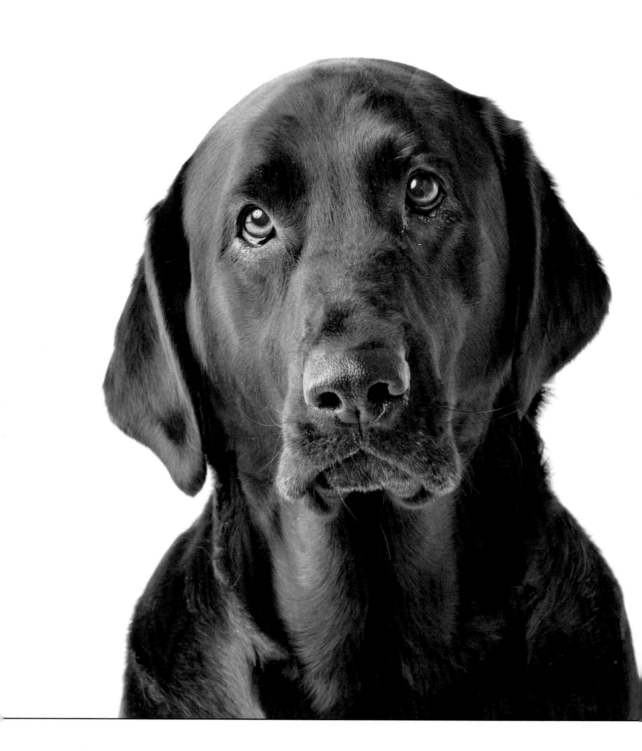

1. Easing Into the Dog-Owner Market

I think dogs are the most amazing creatures; they give unconditional love. For me, they are the role model for being alive.—*Gilda Radner*

This process may be less complicated for photographers just turning pro (and I mean, those business cards were just uploaded to a printer) because the public has not identified this photographer with other types of imagery. If you are a studio owner who has been in business for a while, especially if you have portrait displays in places of business in your town, this transition can take a little bit more time. Eliminating your people clients and launching a dog campaign is not something that should be done overnight.

My studio's transition was a gradual one. For years at LBI, we were working with the whole kit and caboodle: families, seniors, maternity, babies, and pets. I had a recognizable style—candid, fun, and colorful. I'd found a clientele—middle to upper-class families who valued the boutique experience. I'd even found a charitable cause to support. It was through a Humane Society event,

Facing page—Give me an expressive dog over a crying baby any day. **Above**—Dogs do smile. I've seen it with my own eyes.

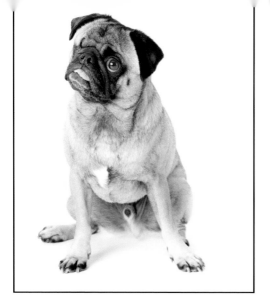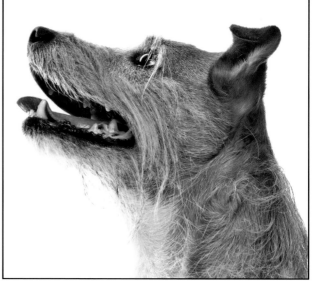

Left—Who would know that a session spent with a one-eyed Pug could be such a great time? **Right**—I am a dog magnet. There was no denying that fact when I started coming home with dog hair all over me.

"Paws . . . for a Cause," that I found my passion for dog portraiture. This fund-raiser grew from a two-week event to one month (February, when business is a bit quiet in many studios) and finally seeped into the day-to-day session rotation.

At the end of that first year that included Paws . . . for a Cause, a review of my profits yielded an important discovery. Our most profitable month was February! This was great news because I had fallen in love with working with dogs and their owners and was ready to slowly change up our marketing plan to appeal to these potential clients.

WAYS TO EASE ON IN

When I did a consultation with our people clients, which frequently involved walking through a family's home, I always scanned for canine activity. If there was a dog in the house, I observed how much attention was paid to the animal. Of course, dogs were always invited to participate in our session, and I finished up the portrait-making experience with some solo images of their furry family member. I was surprised at how many times the family would purchase at least one of these images. True dog lovers consider their dogs to be part of the family and often believe they warrant their own spot on the wall.

Past clients who were known to be passionate about their dog would receive a complimentary dog mini-session coupon in the mail. We sent this out at the beginning of December, with a deadline of January 31st. This is a great time to offer complimentary sessions because it's so deafeningly quiet after the holiday spend-a-thon that clients are recovering from. That first year we had respectable sales in January, a month that is usually spent cleaning out the studio and complaining about lack of revenue.

During this portfolio-building stage, I brought my dog into the studio, as well as dogs that belonged to my family members, friends, our vet, our dentist, my doctor, our cleaner's, the coffee shop owner down the street, etc. You get the idea. I wanted people in our area to know that LBI had a new focus and that we were gearing up for a "man's best friend" cross-over.

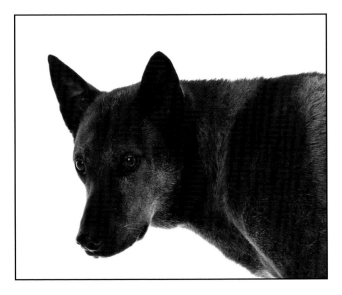 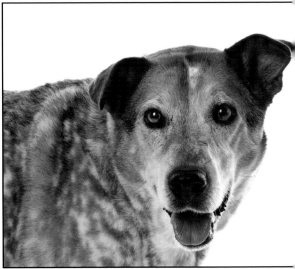

Left—It was great to get unusual breeds in the studio. It helped me work with all kinds of dogs. **Right**—It took me a while to learn how to get dog subjects to look directly at the camera.

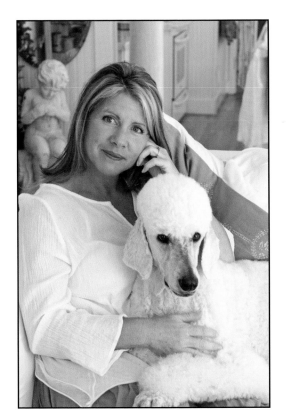 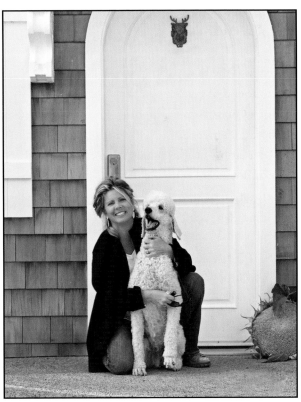

Left and right—My friend Leah poses with her dog George in and outside of her beach house. They were both beautiful subjects to build brochures around when I decided to "go to the dogs."

The main vehicle for our new adventure was Paws . . . for a Cause. The power of having a charity that you support that speaks to your niche market is incredibly valuable. We will cover this topic in depth in chapter 8.

DON'T LET THE PEOPLE GO

If your two-legged clients are paying your mortgage, it is important not to neglect them. It is possible to incorporate dog clients into your day while maintaining a steady flow of people-only sessions. The good news about dogs is that the sessions do not have to be long, and the prep work for photographing them is limited.

An architect in the area poses with her beloved Golden. They exhibited a great bond that was fun to showcase in marketing materials.

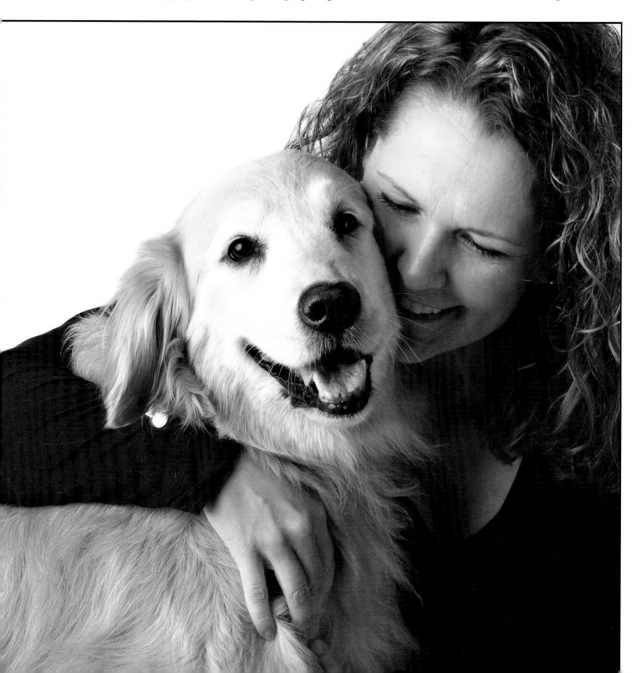

I promised the woman I adopted Fauna from that I would continue to dress her little princess. I've been true to my word.

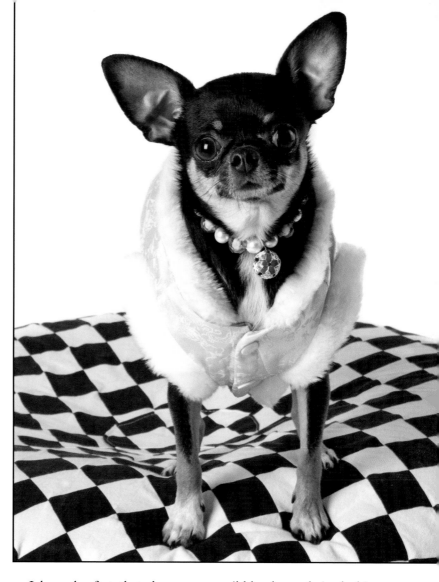

I love the fact that dogs never quibble about their clothing choices.

I love the fact that dogs never quibble about their clothing choices (unless they are a quietly suffering Chihuahua in a purple jacket like my little Fauna). They do not grouse about their hair and makeup. I've never had a dog ask me, "Can you make me look thinner with Photoshop?" Ah, we do love our dog friends.

I did my own thorough evaluation of what the dog-to-people ratio would be for our studio. The dream was to have 70 percent of our studio time revolving around dog sessions and the remaining 30 percent comprised of magazine-style family sessions. I had always dreamed of a niche in the people market as well and thought, "If I can do this for dogs, why not create a side niche for people as well?"

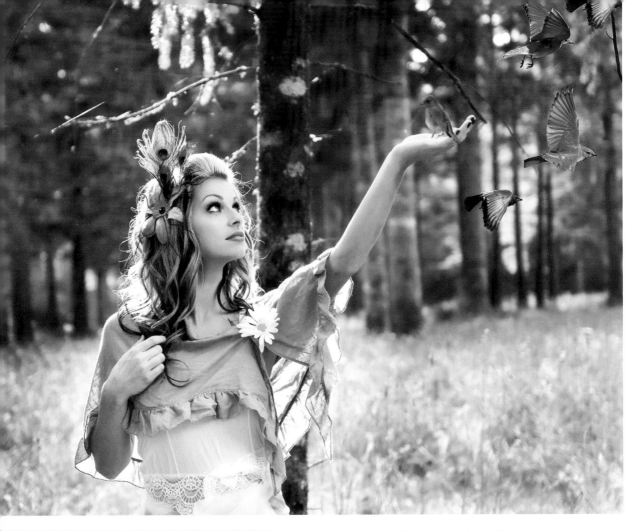

Top—This image, called *Keeper of the Birds*, was made during one of my break-out-and-try-something-new sessions. **Bottom**—This image is one in a color series that I did with several families as a way to challenge myself and do something different.

Love affairs with tennis balls make for a nice personality shot for an owner. It takes several tries to get this shot, but it's worth it.

Thanks to our busy canine schedule, those human sessions became more in demand, and I was able to charge accordingly, booking qualified LBI fans who were willing to invest. My advice would be to rotate these dog sessions in and see if it's something you can see yourself doing all day. Ask yourself if you would miss your people sessions. Would you be sad not to dress up babies anymore? Would you miss the silliness of working with small children? Dogs come with their own challenges, and I've met photographers who are amazed that I don't tire of the slobbery tennis balls and hair-covered backdrops. For me, it's all part of the fun.

WORKING AROUND PET ALLERGIES

Let's say you're a dog-lovin' photographer who also happens to suffer from stuffiness and puffy eyes during dog sessions. What to do in this scenario? If your nostrils plug up at the mere sight of dog hair on your backdrop, perhaps there should be a select day(s) that you work with dogs. That could be your "allergy medicine day," and you can take all of your dog sessions back to back. Or, if it really is unbearable, you might want to reconsider this portrait avenue. As sad as that sounds, it's important to take your quality of life into account when you determine the kinds of clients you photograph.

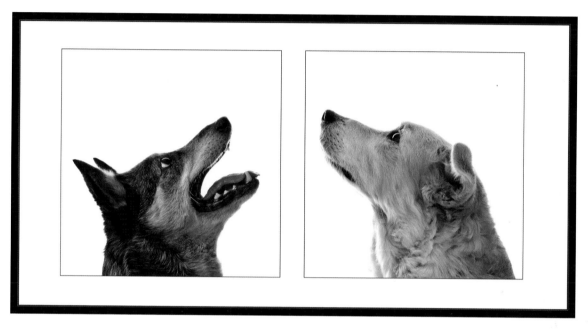

Facing page—Looking straight down into the sparkly eyes of a dog makes for a great image. **Top**—Profiles of pets are fun to play with in Photoshop to create artistic collages. **Bottom**—The key to making a black dog show up well (eyes and all) is good studio lighting.

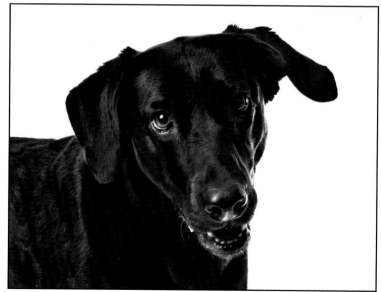

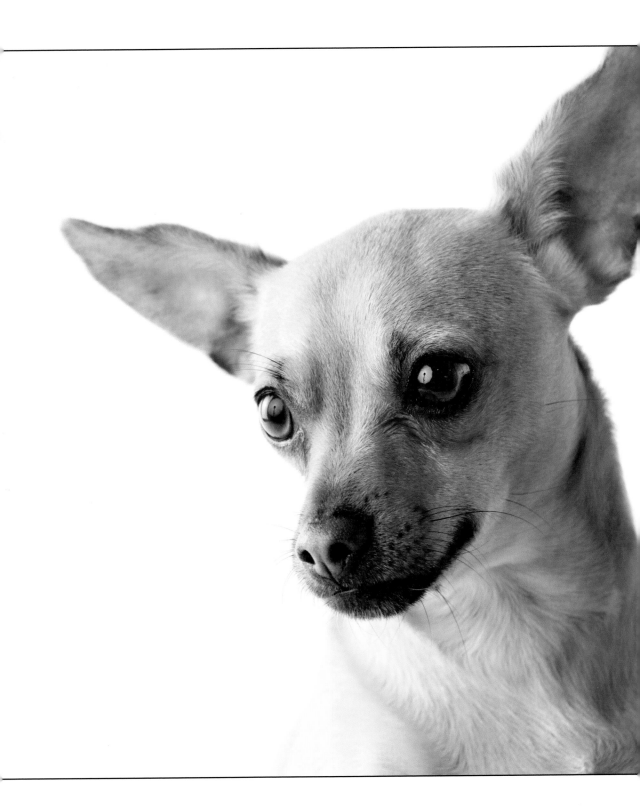

2. Your Dog Portrait Style

I would rather see the portrait of a dog that I know than all the allegorical paintings they can show me in the world.—Samuel Johnson

There are as many styles in the dog portrait world as there are breeds. Sometimes it depends on the part of the country you're living in. For instance, the traditional "hunting dog on a settee" portrait might be more prevalent in a place where hunting is a common pastime. I've seen the "gaggle of puppies" on a couch image many times in the PPA Loan Collection books. There is the "saturated color on-location" look of the urban pet photographer out there as well. How do you choose which direction to go?

In the beginning of my dog-inspired adventure, I took many trips to the bookstore to look at dog books. I paid attention to the images on dog products at pet stores. I even went to dog shows to observe all of the different breeds that are out there. I came to see these creatures as works of art—truly magnificent in their diverse looks and personality. So, for me, the perfect style was to place the dogs on a simple white or gray background to showcase their wondrous parts without competing distraction.

DEVELOPING YOUR OWN STYLE

I have a rule for myself these days. I do not peruse the web looking at other dog photographers' work. There is a reason for this. I don't want there to be even the slightest chance that someone else's style or creative ideas seep into my subconscious. I've always been keenly aware

Facing page—Catchlights in both eyes are achieved in this studio image by moving the main light close to the dog and at a 90 degree angle. **Below**—Small dogs in clothing look great at every angle. The Burberry coat that this client had made for her dog deserved its own close-up.

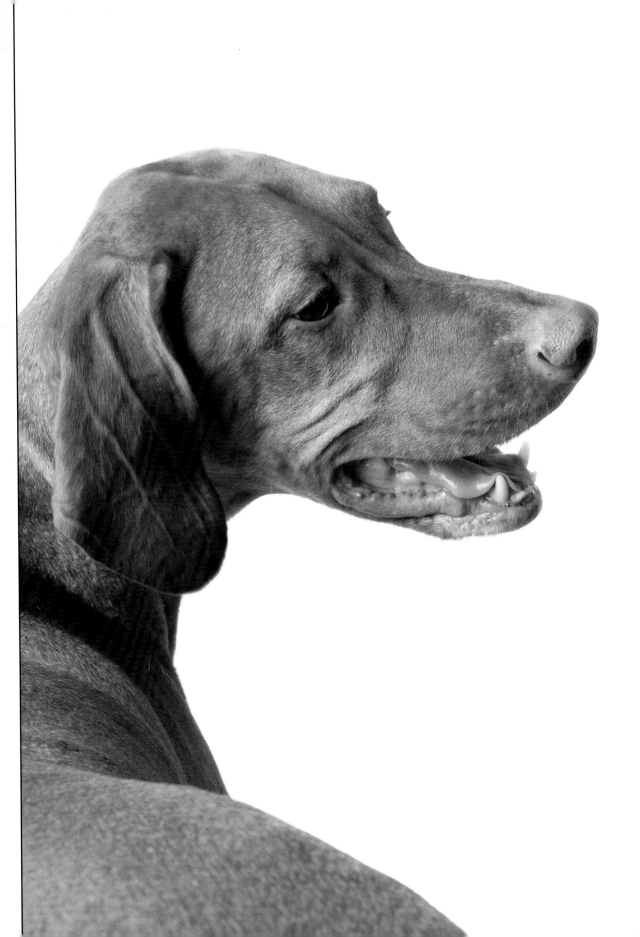

Facing page—Remy, a Vizsla, looks like a work of art to me. **Left**—Vito's ears are alert with the promise of a treat. **Right**—A dog in a crown was in a book at a bookstore I visited. This image was easy to replicate with the right subject.

that being an original makes you irreplaceable. In an industry as creative as photography, finding your own style is the most important thing you can do. I keep a notebook in my purse, and I write down ideas as they come to me—yes, some of them are inspired by what was mentioned above (dog books, pet product images, etc.), but tweaking them to make them your own is the best part of this process. I also journal each day, and many of the ideas we shoot at the studio and on location come from this daily writing ritual.

YOUR IDEAL CLIENTELE'S DÉCOR

Ask yourself what your dream client would look like. Do they live in the city? Are they farmhouse-owning country folk? Are they design-conscious suburbanites? Once you figure that out, ask yourself more questions that will help you pinpoint the dog portrait style you think they would

appreciate. Would they favor images with warm, rich tones or cool, light tones? Funky and whimsical, classical and traditional, or minimalist contemporary portraits?

One nice thing about the simple style of an LBI dog portrait or collage is that it can work with pretty much any kind of décor style, yet it has particular impact in a contemporary space. We're fortunate that so many of our clients live in modern high-rise lofts in Portland, Oregon, that are clean in design—and that they have large walls to showcase these works of art.

While you're contemplating what your target market would like, don't forget to genuinely assess what style you like in pet portraiture. If you don't appreciate traditional, old-world décor, photographing hunting dogs with a tapestry behind them might not be something you enjoy doing day after day. Not enjoying the setting where you work is one way to burn out quickly.

I think the key to authenticity in the creation of any portrait is to be known for a style you truly appreciate yourself.

BRANDING

After you've decided on the style of pet portraiture you're going to pursue, it's important to brand your studio with a logo and a color palette that fits this style. All aspects of your studio marketing should include this branding. Brochures, packaging, stickers, mailing labels, and studio signs should reflect your brand clearly. For example, in our branding we use mint green, black, white, and black polka dots. It's whimsical and modern, and the green gives a natural, earthy feel, as the studio is located in the Northwest, where

Above—Negative space in an image can create a fun visual for an art piece for a dog owner's home. **Facing page**—These two images were hung together in the client's home. It's a fun and whimsical display that serves as a conversation starter.

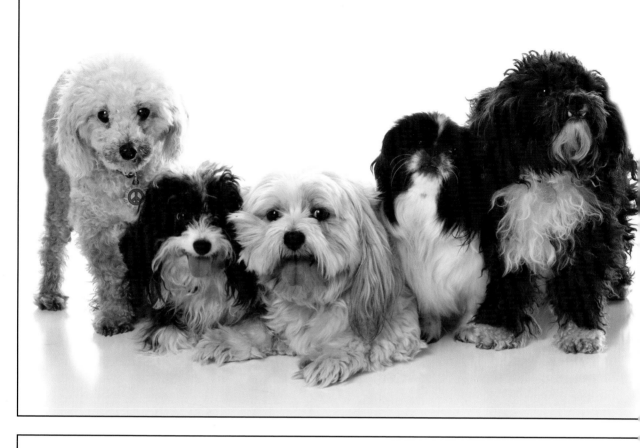

A dog trainer needed images for her business and her home. White backdrop images were well-suited to the simple décor of the training facility, but images with warmer tones were required for a display in her home.

all things are green (literally and figuratively). We also include the use of people and dog silhouettes on our web site and printed materials. I actually captured dogs in the studio with backlight to get the silhouettes of the dogs we feature. This ties in nicely to the note cards and jewelry products we offer, which feature pet silhouettes.

If your branding is traditional, like the hunting dog image example I gave above, perhaps your marketing materials should feature warm colors and your studio décor should lean toward dark woods and traditional design. Leather sofas, dark wood frames on display prints, and hunter green pillows—these are things that, to me, would seem to appeal to someone looking for a traditional portrait of their dog.

A clean-lined, modern approach to branding might yield a studio that is white with industrial décor. Black leather or slip-covered sofas, thick

black frames on display prints, and fun whimsical geometric patterned pillows—these visuals pop into my head when I think of projecting a modern brand.

LOGOS

Your logo should reflect your style more than anything because it will be the most identifiable part of your brand. For instance, if your studio becomes well known in your area, your logo should immediately conjure up a feeling of the style that you project in your pet portraits. I had my logo done by a professional graphic designer years ago. After several attempts at coming up with one myself, I realized that the fact that I'm visual and can take a great picture doesn't mean I'm skilled at creating a logo. There are so many photographers out there who also make a living creating logos. I think that photographers who have

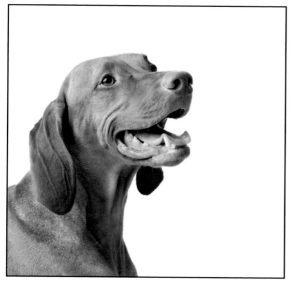 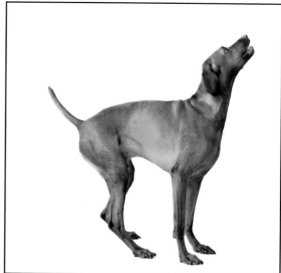

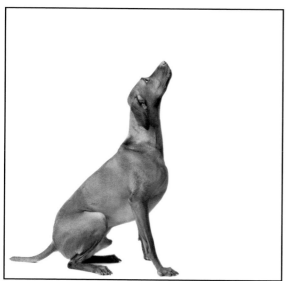 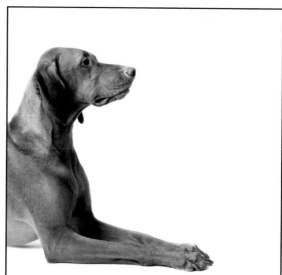

This collage of Remy is hanging in my own studio because I love how it showcases his beautiful canine form and his personality.

strong graphic design skills are perfect for coming up with a studio logo because they know first hand how important it is to their own success as a photographer.

Be careful about changing your logo. The public can become confused about a business' brand when the logo is changed frequently. If you are crossing over from people portraits to dog portraits in one fell swoop, a logo change might serve you well in that your new clients will be "starting fresh" with your new studio vision. I still have sessions with people, so I decided to keep my logo the same. I like the clean lines and high-end feel, and I want my clients to know they'll be making a significant investment with our studio.

MY OWN HOME: HANGING WHAT I SHOOT

We're not talking about taxidermy here. When

Top—I wanted a logo that was sophisticated because I work with a high-end clientele. **Bottom**—Many of my image displays are squares, so I decided to print square business squares to reinforce the LBI brand.

Top—I shot my own silhouette in the studio for this gift-certificate layout. **Bottom**—Designaglow.com had several wonderful silhouettes that we purchased to use in our marketing materials.

THE GIFT OF

Portraiture and Design

TO: _____

FOR: _____

LARA BLAIR
images

WWW.LARABLAIRIMAGES.COM
360.834.4814

2010 COVER WINNER:

Punkin

HUMANE SOC.
LOGO HERE

CALENDAR SALES HELP...BLAHBLAH

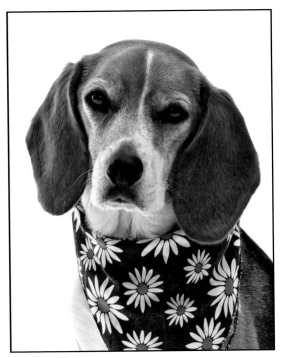

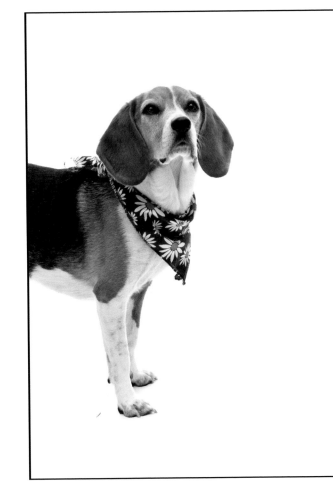

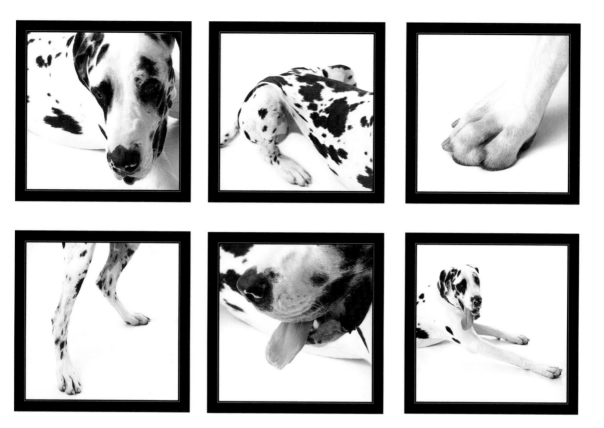

Facing page—*(top left)* Daisy was a rescue from the Humane Society when we lived in Warwick, NY. *(top right)* Fauna was adopted right before a favorite client passed away. *(bottom)* Fauna is the alpha and Daisy pretty much does whatever she says, hence the placement of the two in this image. **Above**—We used a huge display of Bogey's wonderful parts in a local dog daycare. (We call this type of wall art A Sum of Its Parts.) Harlequins are not common, and I felt like he was the perfect pooch for an art installation.

I was beginning my dog art transition, I hung large square portraits of dogs in my studio and also created some dog collage series in my home of my own willing subjects, Daisy, the Wonder Beagle, and Fauna, the "Faun-tastic" Chihuahua. I guess having these works of art around me in all of my environments helped me see a style developing, and it was a source of inspiration.

I found that I was very drawn to squares. I was also drawn to the parts of a dog. One of my first large wall collage creations was of Bogey, a gorgeous harlequin Great Dane. He was one of

the most regal dogs I'd ever met and warranted having some dog art created in his honor.

We called this type of wall art A Sum of Its Parts, and to this day it is a big seller at our studio. I'm all about big, and I make this very clear to the clients I work with. Our studio is in the business of creating large installations of dog art. Sticker shock might occur when our clients order, but we impress upon our clientele that we will be installing an art display, not simply hanging up some dog portraits.

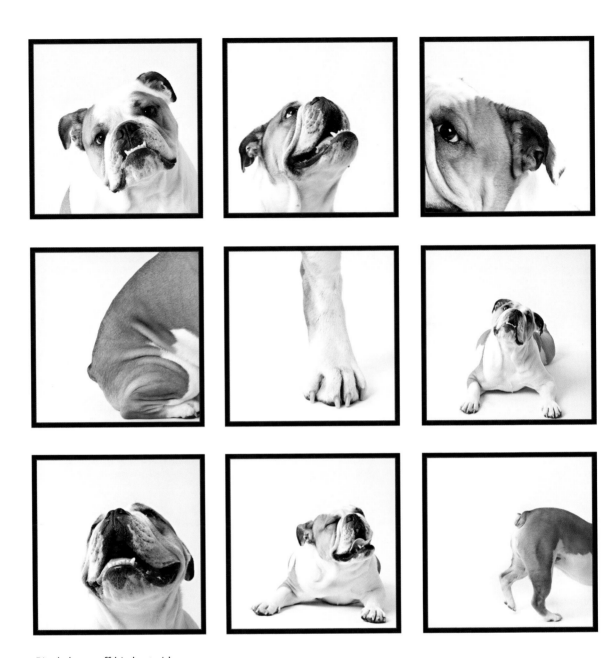

Rigel shows off his best sides.

BEING AN ARTIST AND BUSINESSOWNER

Presenting yourself as an artist is critical, as it will help your clients see that the investment in your portrait art is worth it. They need to believe that you see yourself as an artist and not just a studio owner. I try to exude the artist role in everything that I do—the way I dress, the look of the studio, the marketing materials that go out,

I projected this image so that a client could see that a 20x20-inch print would fit in her hallway.

etc. I even created a separate blog for my "artistic life" called Modern Prairie Girl (Modernprairie girl.com) that includes information on interior design, the art world in general, and my own creative endeavors outside of the studio. Many of my clients are frequent readers of this blog, and I try to "cross-pollinate" by including a link to the LBI blog as well.

I really want my clients to know that I am completely invested in creating a jaw-dropping display in their home with their beloved animal and that I am qualified to tell them what to purchase. Frequently I will do consultations in the client's home before the session so that I can take notes (and pictures) of walls that need

art. It is such a powerful thing during the ordering session to display an image of a client's wall with a superimposed dog portrait placed on it in Photoshop.

People get overwhelmed! They need guidance for their wall displays, and if you earn their trust, you just might end up with an incredible sale. Be familiar with design and how your work can complement it.

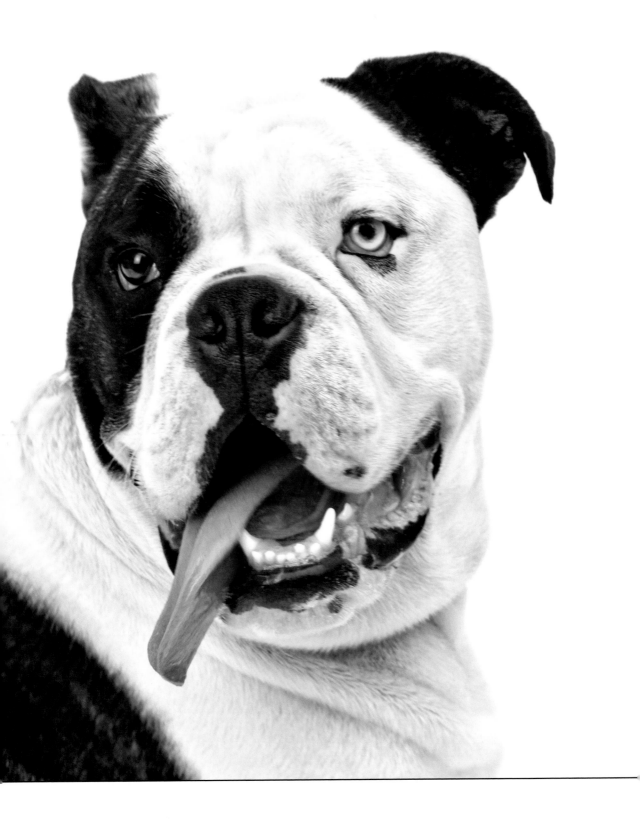

3. A Doggone Good Marketing Plan

If you are a dog and your owner suggests that you wear a sweater,
suggest that he wear a tail.—Fran Lebowitz

One thing I've learned about working with dog owners is that people who see their dogs as children will invest in portraits and other studio products. Anyone who is shelling out a significant amount of money for weekly dog daycare, spendy little dog sweaters, and organic food is someone you want to reach with eye-catching marketing. They want the best for their pet, and you will need to communicate that, in your area, you are the very best at photographing dogs.

If you choose the right location for your portrait displays, you can reach a prequalified audience. The obvious choices are vet clinics, animal hospitals, dog daycares and dog hotels, pet boutiques, the Humane Society, and other shelter

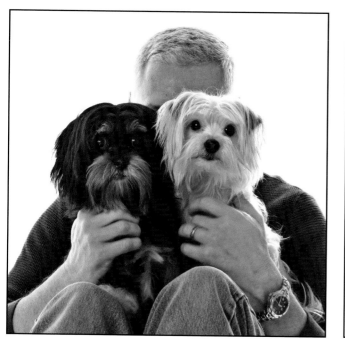 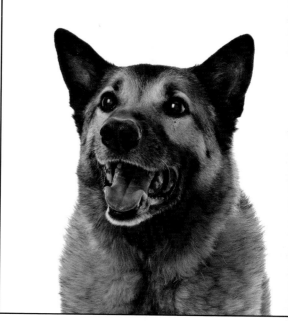

Facing page—After your business goes "dog wild," you'll need to figure out how to best reach your target market. **Left and right**—Dog people are special, and they need a special marketing plan.

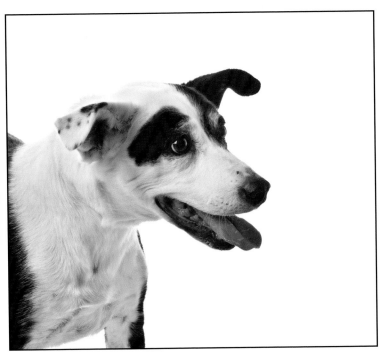
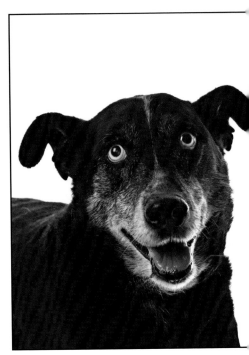
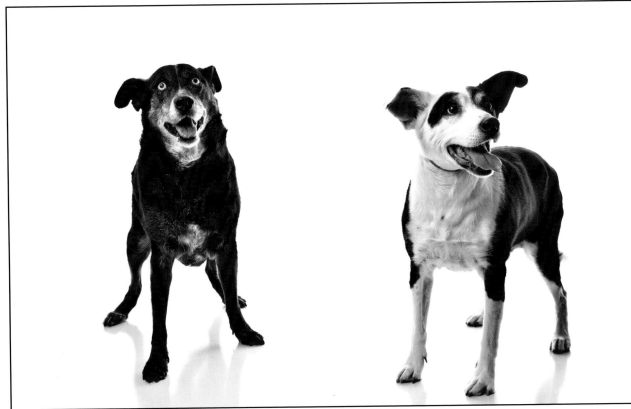

Facing page—Debbie's dogs were her children. The images she purchased were cherished and put on display. I honor her memory by giving them the best-possible experience during their sessions. **Top**—Dr. Tracy called us right away to install a wall of dog art in her clinic. **Bottom**—I chose only my favorite images to showcase the style I was aiming for in dog portraiture.

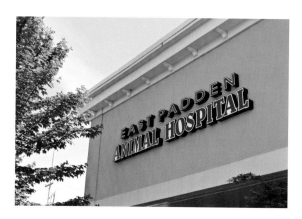

facilities. These are places dog owners come in and out of every day.

It's important in working with these businesses that the location is a good one. The best locations are places where your ideal client will go. I've racked up significant display expenses by staging displays in a couple of pet-centered businesses that were not optimal for my needs—for example, near the high-rise lofts I wrote about earlier. I live in an area that is thirty-five minutes over the state border from a major city. This suburban area is not ripe for selling expensive dog portraiture. We work with families who make large investments in portraits, but having a 20x20-inch print of their dog's face is not the usual scenario for the clients in the area where my studio is located. Most of my canine marketing goes on in the city, and I have put a lot of effort into building relationships there.

VET CLINIC DISPLAYS

I started by sending out a packet about our studio to several clinics in the area. I received calls from two of these clinics, with one ending up as the new vet for our dog and a place to display our work. Dr. Tracy at East Padden Animal Hospital was a joy to work with and was game for whatever dog art we wanted to place in her clinic. We did a complimentary session for her, her husband, and two dogs and created a wall display that is in the line of sight from the front door. I think it is wise for vets to have images of themselves with their own pets to show that animals are a big part of their non-clinic life.

I gave Dr. Tracy three complimentary sessions to give as gifts to pet owners who had made a substantial investment in her clinic. After we

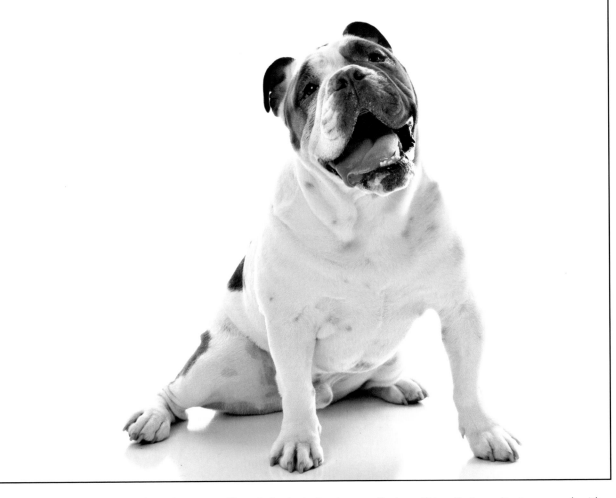

Consider portaits of a wide variety of breeds for inclusion in your displays. This will show clients you work with them all.

captured these folks in the studio, we "gifted" them an 8x10. I think it's really important to include a print when you're giving complimentary sessions to anyone, because they need to feel that they're getting something tangible out of the experience. Although as photographers we know that the gift of time and talent is a significant one, clients who are receiving complimentary services from us need to hold something in their hands to understand the magnitude of the gift. I tell the vets that I work with that a gift like a

portrait session will be seen as a gesture of gratitude to their patients that will impress them. It's that "something extra" that sets them apart from other animal clinics.

I also gave Dr. Tracy gift certificates to give patients who own dogs that are near the end of their lives. We have worked with so many clients who want that "last great image" of their dying pet. These sessions are so emotional for me. I can't help but get caught up in the sadness of it all, but I think it's really a valuable thing to

provide someone who is in love with their dog. We provide an 8x10-inch print for them after the session. When word comes from the client or their vet that the dog has passed away, we send a frame ornament with an image of their beloved and a card from all of us at the studio. I believe that this kind of customer service for a client (who might not even purchase any prints from us) shows that we are a studio who cares about dogs and their owners. Frequently, we will be repaid for our efforts with a great deal of word-of-mouth advertising. I feel honored to take that last image, and I never regret doing these kinds of sessions. In addition, you better believe that when the client is ready to get another dog, we will be their first choice in pet photographers.

Top left and right—Designer breeds, like these Chi-weenies, are great subjects for displays. **Bottom left and right**—This woman owns a dog-washing boutique, and we decided to showcase her with her dogs in the store display.

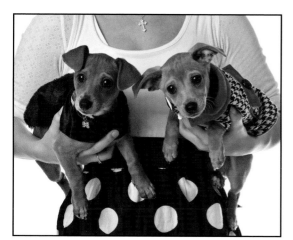 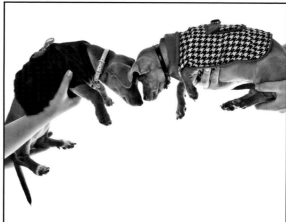

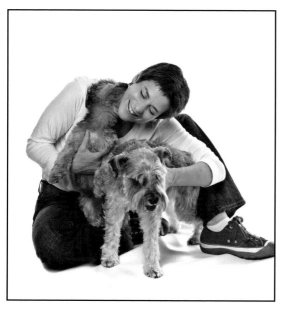 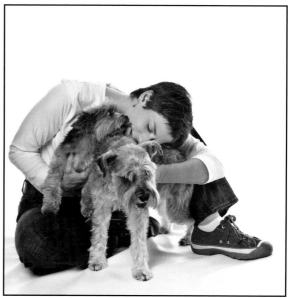

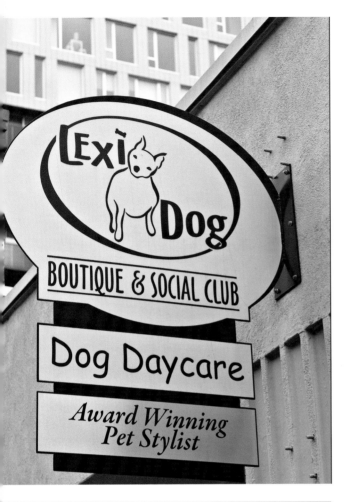

DOG DAYCARE DISPLAYS

My city is one of the biggest dog-centered cities in the United States. People here spend a significant amount of money on their pets every year. As you might expect, there are numerous dog daycare centers in the area.

When I made the big decision to concentrate my efforts on dog portraiture, I spent a day researching all of the dog daycares in a thirty-mile radius. I looked at the location, clientele, available wall space, Internet presence, etc. I came up with five that I thought would be the perfect fit, and I put together knock-your-socks-off packages with our marketing materials, sample images, and a cover letter addressed to the daycare owners. After months of not getting any response, I began to get a little discouraged, but I found that there are other ways of getting to know these folks and building a relationship.

I attended dog events in the area where I wanted to gain clients. I found that dog fairs or expositions (e.g., a dog show) at our local event arena were not the way to reach the folks I wanted to work with. I had built many relationships with dog walkers, groomers, dog trainers, dog massage therapists, and even dog cookie bakers by giving them complimentary sessions. I wanted these people to associate good dog portraiture with my business and recommend me to their clients. It was through these relationships that I was invited to participate in exclusive dog-owner events in the high-rise loft community in our city. Serendipity stepped in and my booth was placed

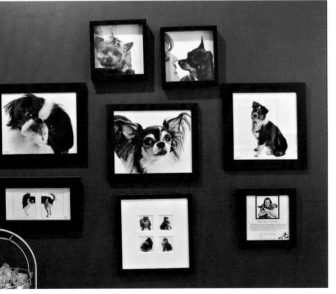

Top—Lexi Dog is a favorite dog daycare among working professionals in Portland. **Bottom**—I photographed Suzanne and her dogs for a display in their lobby.

Top left—The infamous Lexi and her mama. **Right**—Clearly Lexi has done this before. **Bottom left**—This event introduced me to a wonderful and influential woman in the dog community in our city.

right next door to the queen of the dog community in our city. She remembered the packet I had sent her months before. She was personable and fun, and we spent the whole afternoon talking and laughing. I even photographed her dog while I was there and, of course, sent her some prints a few days later. That was the turning point.

Another serendipitous event was that an animal trainer who I had done complimentary work

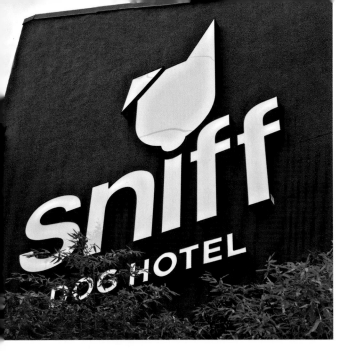

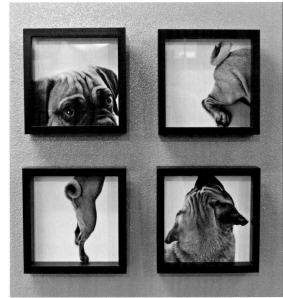

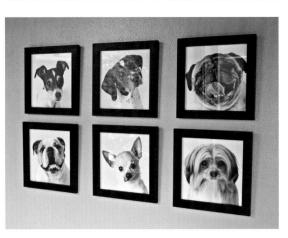

Top left—Sniff Dog Hotel's clean, industrial style fit our brand like a glove. **Top right**—We created a "Wall of Fame" in the downstairs lobby of Sniff. We try to feature images of different Sniff clients every few months. **Bottom left**—They had a perfect wall for an art installation. **Bottom right**—Again, I chose only my favorite dog faces for this display.

for was hired at a new high-end dog hotel in the city. She put a good word in for us (saying that we were "the best"; how great is that?) and the owner called us to do an installation of dog art on the second floor where the dog "hotel rooms" were located.

This relationship proved to be extremely valuable, as we were able to photograph dogs at their facility. It was a win/win in that the hotel provided their clients with something special and we were able to work with an amazingly qualified clientele—people who want the best for

their dogs and are willing to invest in the pet industry.

WORKING WITH PET BOUTIQUES

There are two kinds of dog-centered retail stores: the retailer that looks more like a warehouse with racks and racks of food and the boutique owner who is looking for the hottest new dog accessory to offer their urban clients. This second type of shop sells high-end dog gear, food, toys, etc., and caters to people who invest in their dogs frequently—my dream clients!

Images made for a boutique need to be "boutique-y" in style.

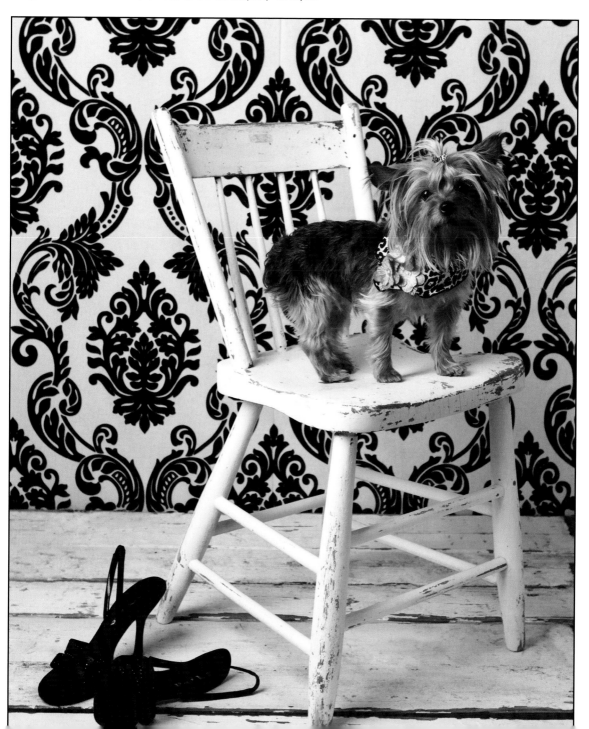

Left and right—These two dogs are Wall of Fame rock stars. **Facing page**—Dogs with unusual features like two different-colored eyes grab a person's attention.

I feel it's a good idea to offer these shop owners gift certificates for their best customers. Dog owners who shop consistently at the same store will trust the store owner in recommending dog services, including portrait studios. Again, a gift from the owner allows them to show appreciation for their patronage, and it costs them nothing. I always offer to put up an image display of their best customers' dogs (complimentary, of course) in their shop. I point out that creating a "Dog Rock Star" wall can help them in that these customers will bring in their friends to show off their dog. These friends could potentially become new customers for the shop owner. Of course, I will ask to place business cards next to the display so that everyone who enters the store can see what we do.

When I approach a dog boutique owner, I always make sure they haven't already partnered with another photographer. I'm careful to honor the relationships other photographers have fostered with businesses. It's not a good idea to assume you're the only dog photography show in town. I always think about how I would feel if I knew another photographer was trying to land a display in a store that I've put a lot of time and energy into. I believe there's enough business to go around, but it is extremely important to develop your own style so that you stand out to these dog boutique owners (see page 45).

THE DOG HOTEL MARKET

We have some very swanky hotels in our city that cater to dog owners. Frequently, these hotels are run by large corporations, so contacting the right person can be challenging. Yet, sometimes these little boutique (there's that darn word again) hotels will be locally owned, and meeting the

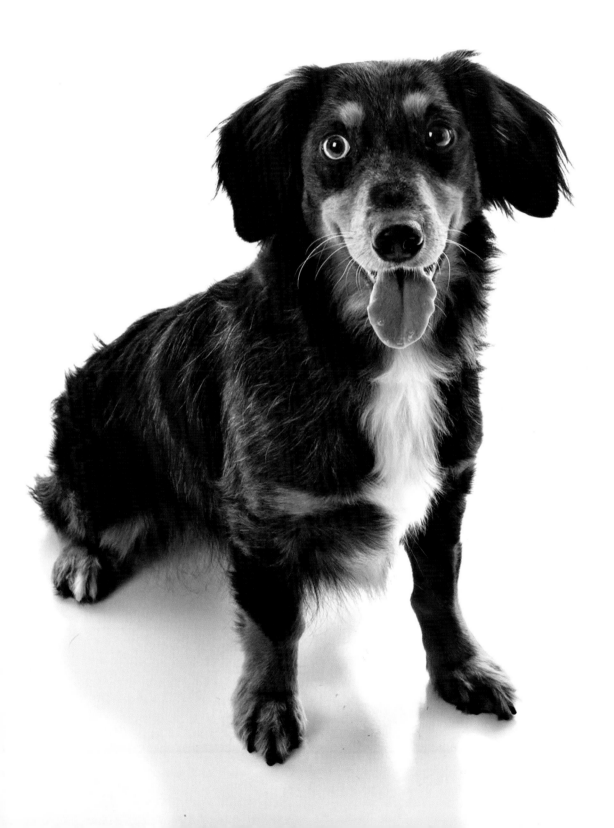

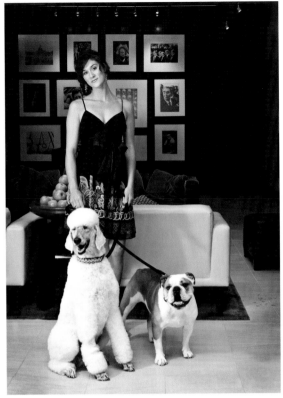

Left—Going on tour was a great way to reach the dog community on the west coast. **Right**—Hotel Monaco was the perfect setting for this model and some well-chosen dog friends.

hotel manager is enough to get your foot in the door.

The summer that I decided to really go for it with the dog market in the "big city," I contacted one such hotel and asked if I could have a "portrait tour stop" in their facility.

Being that a large portion of their business revolves around dog owners (complete with dog beds and fancy meal dishes in the rooms), they were open to the idea. After some great conversations and relationship-building with the dog-loving hotel manager, they agreed to allow me to do the sessions in their front lobby. We hand-picked dog community hotshots in town and gave them gift certificates to come to this

beautiful hotel for a fun session experience. The exposure we got from being just outside the elevators was fantastic. Whenever there are flashing lights and cameras clicking, people are bound to gather! A gathering crowd makes for a perfect opportunity for handing out business cards.

Although the net sales from this experience weren't staggering, the exposure was. We posted images from that day on our blog; the shots were of a beautiful model and two dogs in front of an art display in the lobby. We ended up using these images in our marketing materials and advertised the hotel as a dog-friendly facility—something that made the hotel manager happy and generated referrals from a good source.

Being an artist-in-residence in a dog-friendly hotel is also a great idea. Having several dog images that are displayed as art pieces show the public that your portraits are appreciated by businesses that are known to support artists. In my opinion, being seen as an artist is the best thing that can happen to a photographer. Art is valuable; it is something people invest in. It is essential to put your best foot forward when meeting with hotel managers. Dress the part, have your work in a beautiful leather portfolio, and speak confidently about what you feel your art can add to the hotel environment.

Being an artist in residence in a dog-friendly hotel is also a great idea.

NEWSLETTER AND E-MAIL BLASTS

Once a month I send out a short and sweet e-mail newsletter to a list of dog owners. The recipients have either asked to be on the list or were automatically added when they sent me a message through my web site. I always choose a Dog of the Month and do a little paragraph on what makes him or her special. I send a card in the mail to the dog owner to let them know their dog has been chosen and the owner, in turn, shares my newsletter with

George is extremely well trained, and I specifically asked my friend if we could borrow him for this shoot because he looked the part of a Chi-Chi city dog.

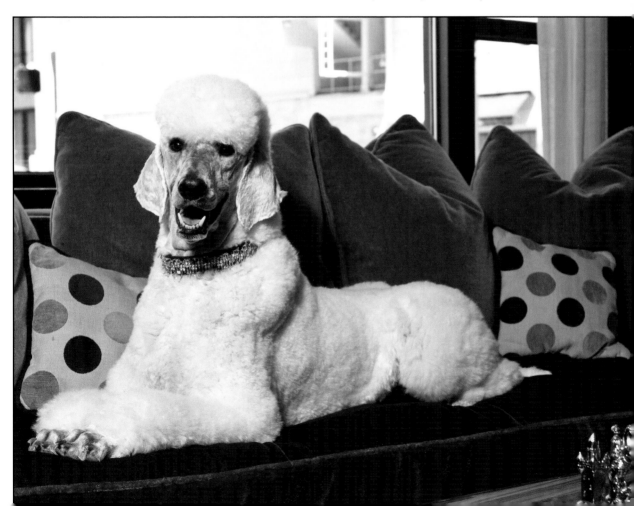

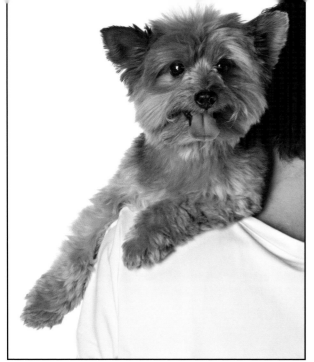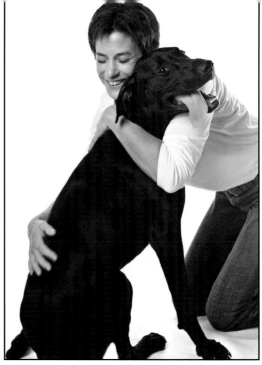

Left—Happy, relaxed dogs make great subjects for web site images. You want prospective clients to know their dogs will have a good time at the session too! **Right**—A dog hug. Who doesn't feel the love?

friends and family. In the newsletter, I also cover upcoming events for charity, exciting new LBI happenings (like being asked to write a book for Amherst Media!), and a personal note about my family and my own dogs. I include links to the LBI site and blog, as well as my own personal blog. Many of my clients follow this blog, which makes me think that they are invested in me as a person as well as a photographer. It seems that the more interested clients and prospective clients are in you, the more they will recommend you to others.

I had the company that did my web site set up my newsletter through Pegmail. It's easy to navigate and gives you an impressive overview of how many people opened your newsletter, who unsubscribed, who clicked on a link, etc. It's pretty slick stuff! I like having that information to help me tweak future newsletters.

YOUR WEB SITE

Your web site is your calling card; it tells the world what you're all about. It's important that it stands out in a crowded industry where many sites look the same. Investing in an outside (qualified) webmaster to create something unique for your studio, in my opinion, is completely worth it. After a failed attempt to learn HTML, I discovered that my time was best spent building my brand, not a web site. In working with a webmaster, you can pay a lot and get all the bells and whistles, but it's not necessary. What is important is that your site showcases your work well through image galleries, projects the brand of your studio, and clearly presents session information. When you're going through the process of building your site, it is helpful to ask friends and family if the site "feels like you" and represents your studio brand.

When photographing two dogs that belong to one owner, I like to have shots that show them together and solo images as well.

Your web site will often dictate what kind of client inquiries you get through e-mail and on the phone. If your site looks high-end and professional with a clear mission statement for the portrait-making experience, your clients will hopefully be serious about scheduling with you, rather than just price-shopping. It seems that web sites that appear generic or look similar to many others out there will elicit the dreaded "How much do you charge for an 8x10?" question. If there doesn't seem to be a style to the photography on the site, potential clients might feel it comes down to price in choosing a studio. This is not the kind of client you want! Particularly with the niche of dog photography, I want potential clients to see me as a portrait artist who will do much more than capture a likeness of their dog. That, my friends, is what separates the boutique studio experience from the mall studio experience.

Be selective in choosing your images for your web galleries. Ask yourself if an image represents your shooting style. Does it look too similar to other gallery images? Is it a creative, unique image, or has it been seen before on other sites? On my own site, I like to represent several image categories: Dogs as Art (creative white backdrop images), Dog-u-mentaries (dogs on location), and dogs with their owners. I share only my absolute favorite images in these galleries. I ask friends, family, and former clients what their favorite images are and I replace the shots frequently. Keeping it fresh and fun will make people who have already worked with you return to the site to see what's new. I have several clients who come to the studio for their annual art piece.

Try to switch out images as frequently as you can. Images you took five years ago may not represent the work you're doing now. Look at your web site through a client's eyes every few months to see if it seems current to you. If you are changing gears to become more of a dog portrait studio, you may want to rotate in as many dog images as you can along the way. Or, you can be brave like I was and take all people images off your site overnight and leave just the dogs! It wasn't entirely cold turkey in that I transferred the people images to my other site, Modernprairiegirl.com. It made it a little less scary. But what I did want was prospective dog-owning clients to see me as an expert on dog portraiture, which I believe is best portrayed by showcasing dog images alone.

SEARCH ENGINE OPTIMIZATION (SEO)

A web search engine is designed to search for information on the World Wide Web and FTP servers and that with SEO, in general, the earlier (or higher on the page) and more frequently a site appears in the search results list, the more visitors it will receive. The gist is that when potential clients do searches (e.g., "dog photographers in Ohio") you want your studio to pop up. I use an SEO plug-in on my blog that enables me to put in key words that will help people find my site. Again, a web designer or webmaster might be better able to do this for you, but once they teach you how to implement SEO, you will be good to go.

BLOGS

It is becoming increasingly clear that a photographer who wants to be successful should have a spot in the blogosphere. A blog (or web log) is the place your clients will come to look for images of their dogs and hopefully send the link on

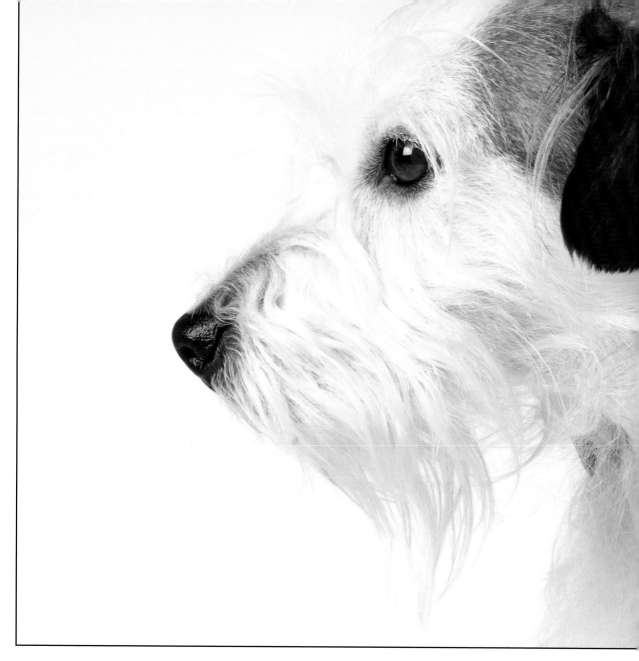

This dog's owner is a "frequent flyer" with LBI. We showcase his dog heavily on our web site because we appreciate his business (and the dog is pretty darn cute).

to people they know. This is the place that you can sing the praises of pet-centered businesses in your area and in turn build relationships with these business owners.

This is also the place where your clients and prospective clients will get a feel for who you are as a person. People are much more inclined to do business with people they like, people they feel they can identify with. I will frequently post images and stories about my own two dogs, Daisy and Fauna. Heaven knows they get into

enough trouble to tell a funny story once a week on the blog! I have had people who also own Chihuahuas and Beagles e-mail me or comment on the blog about their own experiences with these breeds.

It's important to consistently post new blog entries so that people return regularly. I keep a cache of blog posts on my blog administration center just in case I get really busy and don't have time to create a new post. I like to have a new post available every Monday, Wednesday, and Friday. It's also a good idea to have a regular "column" to feature something dog-related. I like to feature products on "Fab Dog Product Monday." It's fun to showcase pet accessories from sellers on Etsy, an independent homemade online marketplace. I also make sure that I feature local businesses at least twice a month. I always drop the seller whose merchandise I am showcasing an e-mail to let them know they've

been featured. You never know who they will send your way! It could be the best client you've ever had.

FACEBOOK

Facebook is an amazing social media vehicle to get the word out about what you do—and it's *free!* You can create an account that features your business name or just use your own name for your marketing, like I did. Be careful if you do it all under your personal account, as you might have quite a few strangers ask to friend you if they know of your business or read your blog. I didn't feel this was enough of an issue for me, so I went with it and mix my not-so-personal updates ("going to a soccer game today") with recent session images ("Look at Rex! Isn't he the most beautiful Golden you've ever seen?"). If you do go this route, be very mindful of what you write. Don't put anything on your wall that

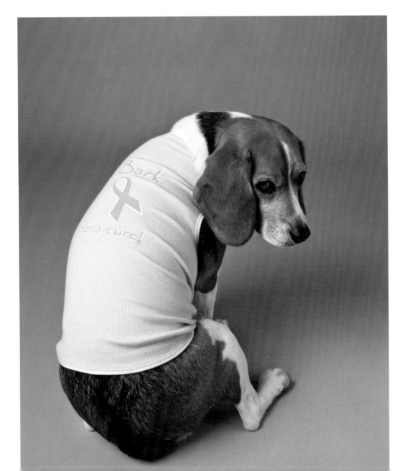

Daisy helped us out with another project I was working on for breast cancer survivors.

"Loved photographing Dana and her new puppy today!" Always tag your human subjects when posting pictures of people and their pets on Facebook.

you wouldn't want to see on the front page of the newspaper.

Having your clients sign a model release is extremely important for many reasons, but especially so when it comes to posting images on Facebook, as a large number of people could potentially see the image.

Image "tagging" is key when posting images of your clients and their pets. Facebook has great tutorials on how to tag someone in an image.

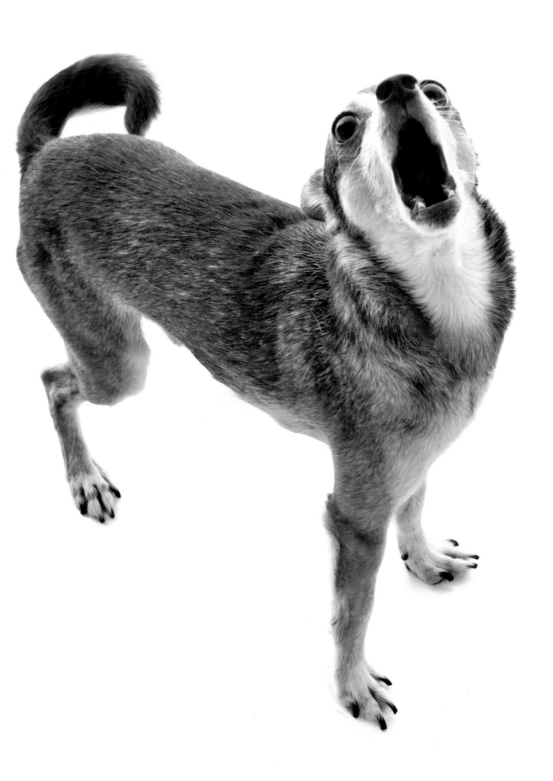

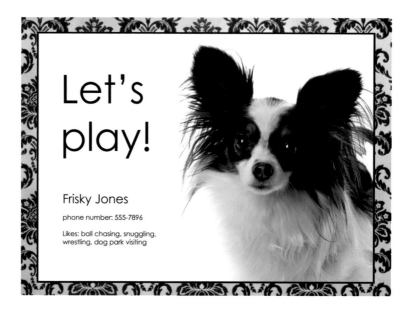

Let's play!

Frisky Jones

phone number: 555-7896

Likes: ball chasing, snuggling, wrestling, dog park visiting

The wonderful thing that happens with tagging is that the image shows up on the subject's wall with your logo on it. I've recently included the ".com" after my studio name on the images so that people will know where to go to see more of my work.

Because we do so much charitable work for our local Humane Society, I will frequently post images of shelter dogs that I've captured on this group's Facebook page. Whenever we do events for the Humane Society, I also post those images with my studio logo.

TWITTER

I've just recently started Tweeting each day about sessions, fun products I've found, or blog posts I've read. You can actually attach an image in a Tweet for your followers to view. I will admit that I was slow to get on board the Twitter train, but now that I have, I can see the value in the play-by-play status on the day. I enjoy seeing what other photographers are working on/seeing/learning about, and I love sharing what goes on in my studio world as well. You can reply to others' Tweets, which helps to build a small community, especially when many of us are photographers. I've learned about some great workshops and products through following Tweets of photographers who always seem to be in the know. I also like to follow pet companies and boutiques to see what product information I can pass on to my clients.

> I've just recently started Tweeting each day about sessions, fun products I've found, or blog posts I've read.

DOG-OWNER FORUMS AND ONLINE COMMUNITIES

In our town we have a great dog-owner network called PDXdog. com. It's a place where dog owners can get to know each other, learn about breed specific meet-ups, and view dog business advertising. It's important to join as a dog owner and not as a business owner first. I never slide studio advertising in my personal posts to people on this forum. I advertised for a while on a separate page on PDXdog.com (which was great), and I kept those two identities separate out of respect for the people who are going to the site to meet other dog owners.

I never slide studio advertising in my personal posts to people on this forum.

DIRECT MAIL

I did more direct mail advertising in the past, but now that our e-mail blasts are proving successful, we rarely send advertisements

I think the backs of dogs are just as interesting as their fronts.

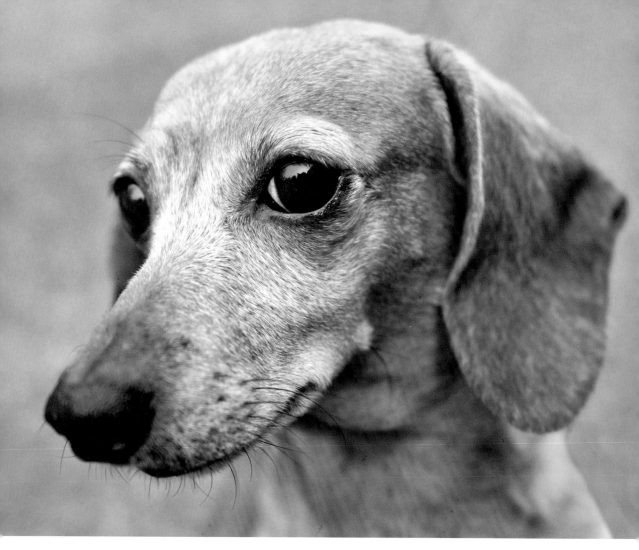

Contemplative and sassy, this Doxie image is always a favorite.

in the mail. Not only is printing and postage costly, but I found that we had very few inquiries from these campaigns. If you decide to do a direct mail piece, you can take advantage of companies on the web who sell addresses of potential clients in your target market. They base their database on yearly income and addresses, and you can choose zip codes in your area that represent this client. Make sure that in the mail piece, you provide a call to action—a deadline for a certain offer—so there is a sense of urgency in contacting your studio, otherwise these pieces might be thrown away without thought. I would try marketing through social media with a call to action before diving into a direct mail campaign. It will cost you very little to get a feel for who responds to your campaign.

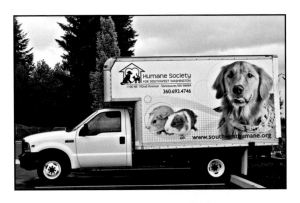

ADVERTISING

Most of our client base over the years has grown as a result of word-of-mouth marketing. Our clients are happy with our service and recommend us to their friends and families. We have found that dog owners are particularly good at giving referrals because a lot of them get together for breed-specific meet-ups at dog daycares or dog parks. Providing calling cards to our clients seemed a little silly at first, but we have found this to be a valuable way for them to show off their dog's pictures to friends at dog owner get-togethers.

Due to the fact that referrals and dog portrait displays in businesses work so well for us, we haven't invested in yellow pages ads or other print advertising. People looking up dog photography in the yellow pages are generally not "our client." Our clients usually see our Dog as

These LBI images are on display for passing traffic to see every day.

Art displays and want one created for their dog. Or the client might do a Google search for dog photographers in their community. That's where search engine optimization comes into play.

ALIGNMENT WITH CHARITABLE FOUNDATIONS

Charitable work and auctions will be discussed in depth in chapter 8, but within the topic of marketing, I did want to make note that it is a good idea to pick a few charities that you desire to champion. Not only is it a great idea to help out these groups with your valuable skills as an image-maker, it makes good sense to have your studio synonymous with a charity that works with your niche market. We offer our services to many charities in the area, most notably the Humane Society. We provide image displays of shelter animals for their lobby, provide sessions for animals that need homes so that they can use the images in their marketing materials, and give talks at seminars at their facility. There is nothing wrong with putting your logo on everything you do for charity, as this is your art that you are providing for a good cause.

I had the opportunity a while back to capture images for the large Humane Society truck that is parked outside their facility. This truck is also parked at all of their big fund-raising events, so many people see it. I provided the sessions and images free of charge, of course, and their staff took care of enlarging the pictures as big as they would go. I almost crashed my car the first time I saw it while driving by a few weeks later. It was spectacular to see the dogs, cats, rabbits,

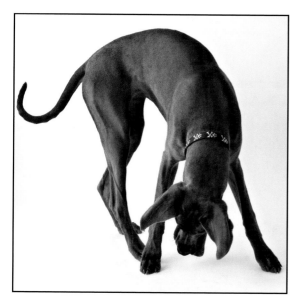

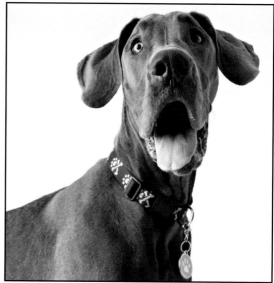

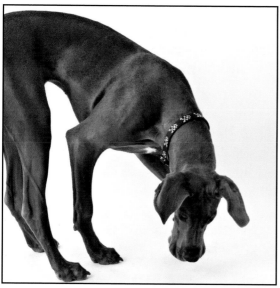

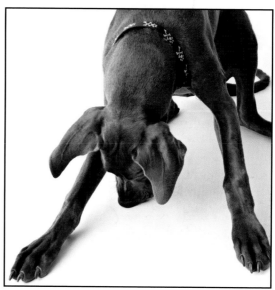

I go into the session with a plan for a collage, especially with a gorgeous creature like this one. Great Danes love to put on a show for the camera!

and guinea pigs larger than life! It was equally spectacular to see my logo underneath them and be able to read it from the road. It was a fun experience, and our studio gained some valuable publicity.

Writing articles for local charitable organizations is also a nice way to give back. Each year I cover "how to take pictures of your pet" in a Humane Society newsletter. I don't worry that I'll be giving away "sacred studio secrets." It's all common sense, actually, like "turn off that flash" and "put your dog in the shade." It's nice to be an "expert columnist" for a month and share information. Keeping your name in front of Humane Society supporters is a very good thing to do for your business.

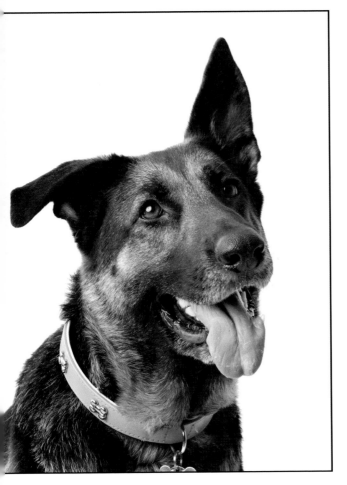

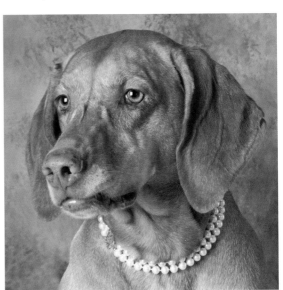

Left—This pooch had a "personality ear" already in place. With the promise of a treat, only one ear went up. Top right—A dreamy warm backdrop worked well for this princess in pearls. Bottom right—This Vizsla is a bit more masculine and sculpture-like. The white showcases him beautifully.

Sometimes an "ears back" image can tell the viewer a lot, like "Why am I wearing this scarf on an 80 degree day?"

SESSION INVESTMENTS

My indoor dog sessions are typically thirty to forty-five minutes and cost less than an on-location session. If the client desires to be in the images, it may be a longer session. Only shooting one to two sessions a day, I have the luxury of not watching the clock. I always have a bit of time cushion on the back end, just in case we go over. I've had sessions where the clients and I just sit on the backdrop and talk and play ball with the dog. I love getting what I call the "after burn" shots—the ones where the dog is just playing comfortably. Sometimes at the beginning of a session a shy dog can take fifteen to twenty minutes just to get comfortable standing on the backdrop. Forcing an animal to sit or stay on it can wreak havoc on the dog's anxiety level, and I really try to let the dog do its thing to get comfortable—even if that means urinating on my backdrop! Gotta love the clean-up factor of vinyl.

I also think that interacting with the dog's owner can help in that the dog sees you as a friend of his or her owner, not a stranger. They

This dog belongs to a groomer who has come to our studio several times. She is a great source of word-of-mouth referrals for us.

will be more apt to perk up those ears when you whistle at them before taking a shot. The ears are the most telling element of a dog's mood. Clients rarely choose images where the ears are back, as this can indicate fear or anxiety.

PRICING YOUR WORK

Of course the price of your art may vary depending on which part of the country you live in, how long you've been in business, and what kinds of products you offer. There is a great deal of discussion going on in our industry about the implications of providing digital files to clients, as well as the under-pricing of work. Personally, I believe it's very important that you feel pride in your work before you decide on your price points. If you're just starting out and are still working out the kinks on your studio experience and image-making, I suggest stepping back from providing portrait services to the public. I know this can be a controversial statement, but if you can't confidently put a price you feel comfortable with on an 8x10-inch print, than there really is question about whether you're ready to make a go of portrait photography as a business. It is not an easy business to make a living with if you aren't absolutely certain that you are providing a fantastic product to your clients.

If you are confident in the images you are selling, don't be afraid to ask your clients to make an investment in your art. It *is* art, and sometimes you might need to gently remind your clients of this fact. I learned a long time ago from

other professionals that if your clients are not complaining about your prices, they're too low. For instance, albums are a product we charge a great deal for because of the design time investment. Hours sitting at the computer are hours not spent capturing new clients and collecting session fees.

Time is money. This is a lesson that many new photographers learn as they look up at their computer screens at midnight, realizing they have spent five hours working on two clients' images. This time commitment to perfection can take its toll on a person's lifestyle. For me, it is best to do "artwork" (editing out imperfections, softening skin, enhancing color, etc.) on just a few of the images and then some basic edits on the others. I also resist temptation to show my clients too many images. Clients who have too many choices may not choose at all, or take too long in the ordering chair. For instance, with a

dog that has come for a thirty-minute session, I typically will show fifteen to twenty images at the most. What's so great about dogs is that you don't get the expressions or closed eyes that you can get with people portraits, thus creating less of a need for ample choices of the same pose. When dogs are comfortable—on the backdrop, especially—I find that I can get the perfect depiction of the dog in ten to fifteen images. I then choose four of my favorites and create a Dog as Art wall display (more on this in chapter 7).

We do offer framing, and I try to keep our frame prices on par with independent framers in our area. It is true that I would much rather have my clients make their investment with prints and studio products, but I also want to be sure that the images make it up on their walls after delivery. Sometimes prints that are purchased without frames can sit on the floor in an office for months before they make it to the framer. We want

Here's one of LBI's custom albums, made for a woman who adores France and her French Poodles.

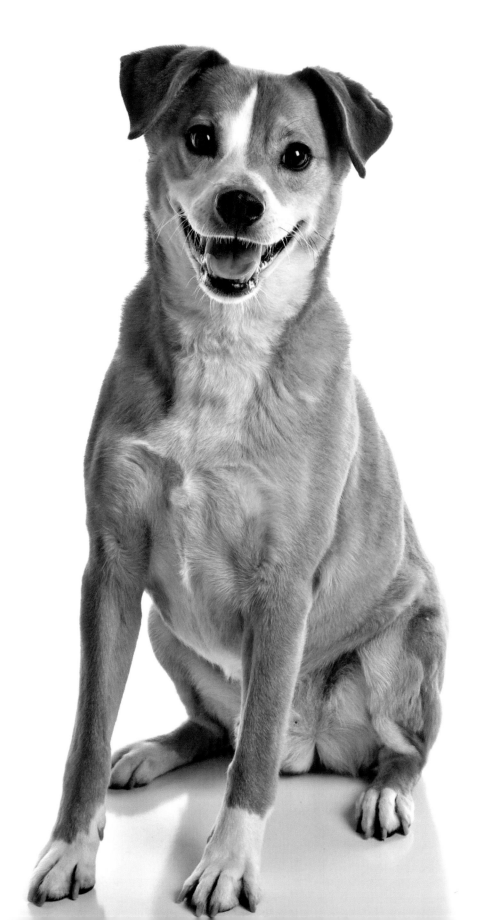

visitors to our clients' homes to say, "Wow! These portraits are fabulous! Who do I need to contact to have some taken of my dog?" Our wall portraits in clients' homes are our calling cards, and we do everything possible to make sure they are put up in a prominent spot in their home as soon as possible after picking up their order.

SELLING DIGITAL FILES

I am not a proponent of selling digital files en masse, nor do I like the idea of doing a session and handing over a CD of images to the client. I feel that both of these practices hinder the progression of the portrait industry in general.

I do, however, want my images to be displayed on Facebook and other social media forums, so I will sell low-resolution images for a minimal fee to clients with a minimum purchase. In the past, I've also "gifted" clients who have made substantial investments ($2500 and up) in our studio with digital files for Christmas cards or social media use. All of these images have my logo on them, of course. I want people to know who took them and come visit our web site for more information.

If I go on a social networking site and see an image on a client's profile that they have not purchased, I will contact them through e-mail and

Facing page—A flattering portrait of a dog is just as lovely as one of a person. It's important to educate people that professional photography makes a difference in dog portraits too. **Below**—Our holiday cards are customized for each client. I take pride in the fact that no two cards look the same.

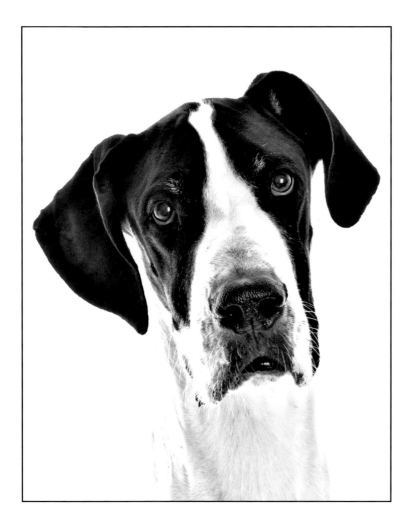

cordially ask them if they would like to purchase the digital file or take down the image. Some people genuinely do not think this is copyright infringement, but I feel it's our duty, as photographers, to politely make clients aware of it. As professionals, we need to do our part to educate the public about what is right and wrong when it comes to copyright. The future of our industry depends on it!

GIFTS FOR CLIENT REFERRALS

We are always grateful to our clients when they send us dog owners who want to schedule a session. A thank-you card is sent to the "referrer" with a gift certificate for $75. They can purchase a print from a past session or apply it toward a session in the future. This has proved to be a great way to gain qualified clients for the dog portrait experience. Dog owners who have worked with us love our work and want to share it with other enthusiastic dog owners—folks who "get" the Dog as Art concept we work so hard to promote.

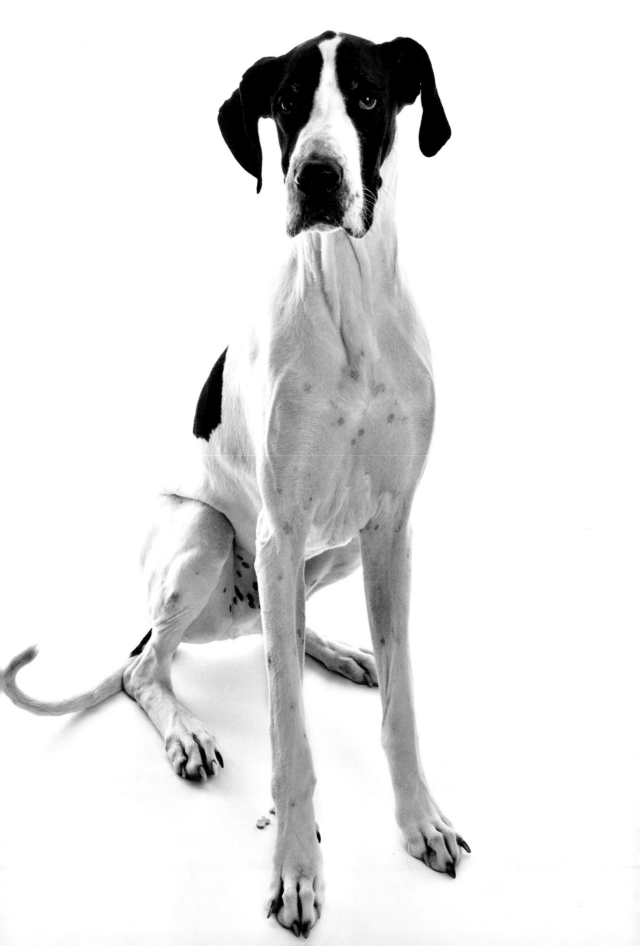

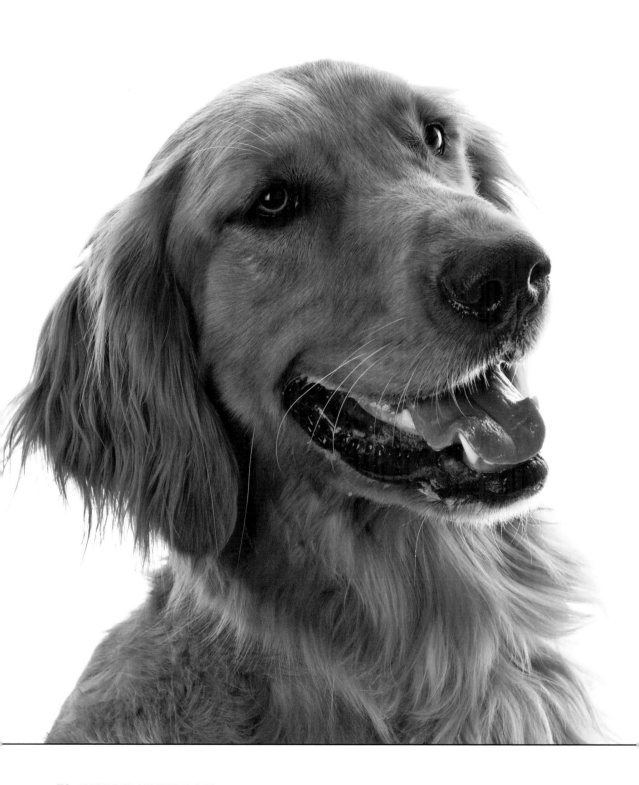

4. Before the Dog Portrait Session

Dogs are our link to paradise. They don't know evil or jealousy or discontent. To sit with a dog on a hillside on a glorious afternoon is to be back in Eden, where doing nothing was not boring—it was peace. —*Milan Kundera*

INQUIRIES

When people call or e-mail us about scheduling a dog portrait session, our first question is, "How did you hear about us?" If they were referred by a past client, I will make a note to thank that person through e-mail. I also always ask them why they've chosen this time in their dog's life to have portraits done and if they've had portraits taken before. For clients who have never scheduled this kind of experience, I think it's helpful for them to understand what we're all about. Due to the success of word-of-mouth referrals and portrait displays, we rarely have inquiries with people who just want a likeness of their dog, thankfully. We make sure they understand that we are a boutique studio (keep using that word!) and that we take our dog art very seriously, but we also know how to have a great time and make it fun for all involved.

Asking clients if they've visited the studio web site is also a good idea. If they haven't, I will have them take a look at it before scheduling a session with us. It's important to me that the limited number of sessions I do each month are with clients who are willing to invest in something special. I quote them a price over the phone and give them a ballpark figure for print prices. This is also a good time to ask them what kind of products they're looking for: framed prints, coffee-table books, etc. I take notes as I talk to them and refer to them later if the potential

Facing page and right—Goldens are one of the most difficult (yet most fun) breeds to work with. They're just so excited to see you and want love during the session. I prefer to work with energetic Goldens outside.

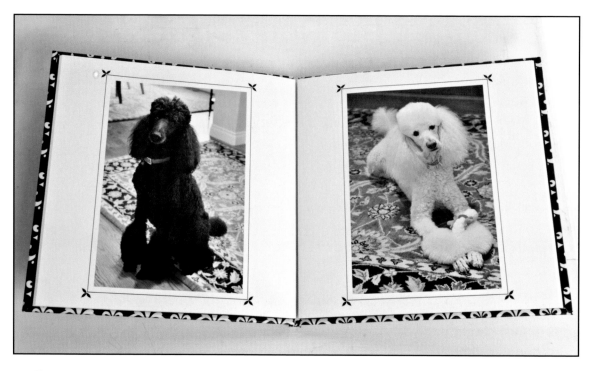

An album is a special product that can be kept on the coffee table for visitors to look through. Presenting the album to the client is always a lot of fun!

client books with us. This is so helpful later when I'm editing the images and putting collections or possible product mock-ups together.

I give clients information on our studio sessions and Dog-u-mentary shots—images made during our on-location sessions. Sometimes clients don't even know they want this type of session until I mention what it entails. For people whose dogs are their "children," a Day in the Life session culminating in a coffee-table book is something they might think is worth the investment.

CONSULTATIONS

I always do a portrait consultation either on the phone or in the client's home before the session day. When time allows, I prefer to visit a dog in his or her own environment. It helps to get to know them a little before you see them again to capture them in action. I like to toss the ball a little and sit on the floor so that they see me as non-threatening, especially with big dogs. The in-home consultation is also a great chance to see what kind of décor the client prefers and determine if there is ample wall space for a Dog as Art display. I take notes about the home so that I can refer to them during the ordering session. When appropriate, I will even snap an image or two with my phone for future reference.

Whether in person or on the phone, I always go over what to expect for session day. If it's an indoor session, I talk about the white backdrop and how some dogs find it suspicious. I remind them that it's okay if their animal takes a while to get adjusted to the studio and that I will be patient in getting started with the capture

process. I suggest that they bring toys or treats to make the process smoother and also give clothing suggestions if they plan on being in the images with their dog. We love jeans and plain shirts with bare feet at our studio, but in the dead of winter not many people like exposing their toes. In this case, I always suggest shoes that won't jump out at the viewer of the image. There's nothing worse than bright white sneakers in an image with a black dog. Also, I remind them to not dress in the same color as their dog, as we will need some contrast in the images. Leashes are a great thing to bring too, but I ask that they bring the least obtrusive leash they own (leave that sparkly pink one at home). Dogs that will not go on the backdrop on their own sometimes require their owner to have them on a leash—and we will eliminate the leash in post-production. It's not my favorite thing to do, but sometimes it has to be done.

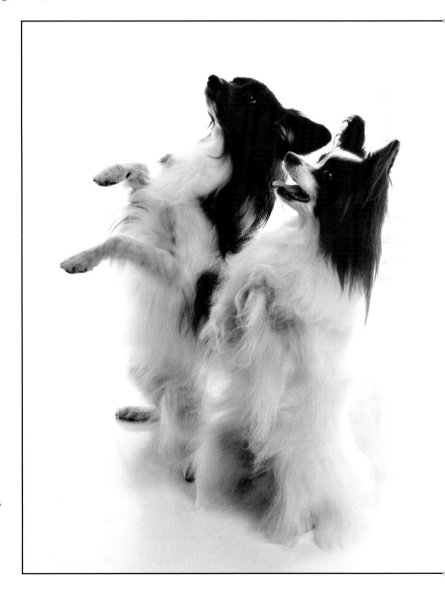

I made a series of images of the sweet pups shown here. The owner selected her favorite images from the session for inclusion in a huge wall display. She said the images make her smile whenever she walks into the room.

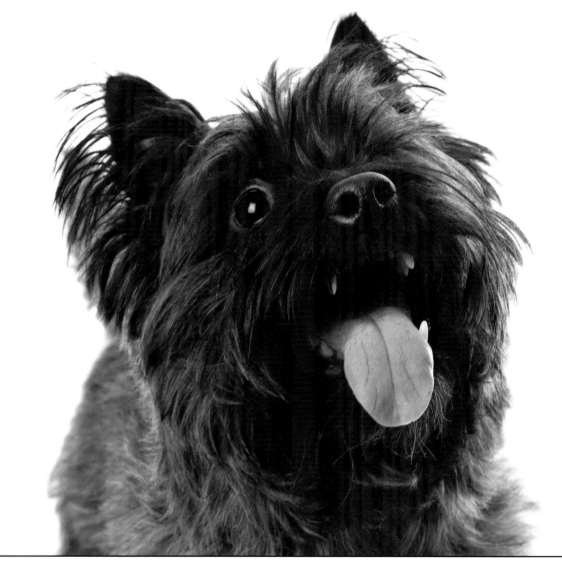

A crisp white background puts all of the attention on your subject and his happy expression.

KEEPING TRACK OF SESSION SCHEDULING

My assistant and I use an online calendar from Yahoo! to input all session information with a password. This way, neither of us double-book a session time slot. You can find all kinds of online calendars by doing a simple Google search. I love being able to pull up the calendar wherever I am when I'm on the phone with a potential client. Sometimes it's best to schedule a session right then and there so you don't lose momentum and have them forget about scheduling an appointment.

Sometimes it's best to schedule a session right then and there so you don't lose momentum.

5. Techniques for Dog Portraiture

A dog is the only thing on earth that loves you more than you love yourself.—*Josh Billings*

THE CAMERA AND LENSES

If you are a photographer who is just starting out, I'd like to give my two cents here about investing in expensive equipment. In line with what I stated earlier in the "Pricing Your Work" section, I believe it's important to wait until you have proficient technical skills to offer your services to paying clients. Investing in extremely expensive gear up front before you are ready can put unnecessary pressure on you to "pay yourself back" with portrait sessions. If you're taking classes or seminars and just figuring out the whole technical side of photography, purchase a camera that won't break the bank. As of this writing, $600 to $900 can get you a great camera. Consumer Reports has a great site (consumerreports.org) that gives the low-down with ratings for different DSLR cameras. Do make sure you're working with at least 10 megapixels when choosing a DSLR. You'll want to decide which brand you'd like to go with because once you choose a camera, all of your lenses will be in a system (Nikon or Canon, for example)—and any pro will tell

you, "it's all in the glass"—meaning the lenses are extremely important in creating images, and you'll want the best ones you can afford.

I am a Nikon girl and use a Nikkor 24–70mm lens for most of my work. A 50mm, a fisheye, and a Lens Baby also live in my camera bag, and I will take them out to play on occasion. But you will find that one lens becomes your

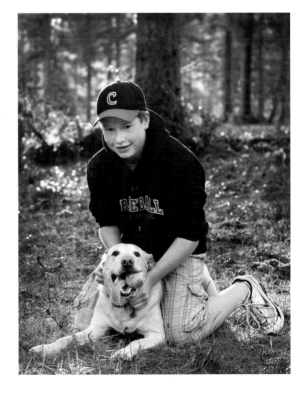

My favorite blurred background is one in the forest. The muddy colors of the trees blend well behind this little boy and his best buddy.

Left—AlienBees strobe with a Larson Softbox. Center—AlienBees strobe with reflector to shoot inside a Hi-Lite softbox. Right—A Larson silver reflector.

"workhorse" and you go to it every time. Investing in a good lens is extremely important. I feel that a camera system rarely comes with the lens you will want to use with dog portraits. An 85mm prime lens (meaning it doesn't zoom) is great for portraits, and some folks even enjoy using a 50mm, but I find a zoom lens is very handy for capturing moving targets on the backdrop. I love the Nikkor 70–300mm lens, but I don't have enough space in my studio to back up and get the whole dog in the shot. It is a fabulous lens for outdoor shooting, though, particularly when working with groups of people, as you can shoot with a very wide aperture, blurring that background beautifully.

For seasoned professionals who are crossing over into pet photography, I think it's possible you'll still love your "workhorse" lens. Your lighting equipment might change a bit in that fur is different than human skin, but it is surprising to me how much cross-over there is from two-legged subjects to four-legged ones.

OTHER GEAR

For people just starting out, keep in mind you will also need to make other purchases as well: image-editing software like Adobe Photoshop or Lightroom, backdrops, light meter, lighting equipment, hard drives for image storage, and memory cards.

Photoshop know-how is extremely important and should be taken very seriously when embarking on a career in photography. There are classes at community colleges, courses online, and even seminars that offer terrific training to photographers who are just starting out. Try as hard as you can to create the best-possible image in camera, meaning the exposure, composition, and white balance are as good as you can get them before plopping the image into Photoshop for editing. The practice of good portrait creation in-camera will pay major dividends later in the amount of time spent editing your images.

Backdrops and backdrop stands will be required for pet photography if you're planning

on working in a studio environment. I have dark backdrops for the lighter dogs and light ones for the dark dogs. I primarily use a white backdrop for most indoor sessions.

When purchasing lights, you might want to consider going with one company so that all of the pieces coordinate or get equipment recommendations from other photographers through networking web sites. We love our Larson softbox light modifiers (there are seven in our studio!), but we use Paul C. Buff lighting equipment. These light modifiers soften the light so that there aren't harsh shadows like you can get with grids or umbrellas. Reflectors bounce the light from one side of the subject to the other for evening out the exposure.

Light meters and white balance targets are wonderful tools for setting your camera for a perfect exposure. I've had my trusty Sekonic meter for eleven years, and I love it. The same goes for my PocketWizard wireless remote. Both of these tools are indispensable.

Image storage will be increasingly important as you work with more and more clients. I like to store my images on two hard drives and also burn two DVDs of all of my sessions. It's a safety thing, and I find that I can sleep better at night knowing my images are backed up and protected. External hard drives just plug right into a USB port on your computer and can store an incredible number of images.

Consider using memory cards that aren't too large for pet sessions. I find that if I'm using a massive card (12 gig or more), I tend to over-shoot. Then I have to edit all of the images, when half that number would have sufficed! I try to capture my sessions like I did in my film days, only pushing the shutter release button when the moment is right. Over-shooting can cause a sore backside that's stuck to your computer chair—avoid it at all costs!

Again, if you're starting out and practicing, practicing, practicing, it isn't necessary to purchase all of this gear at once. Available light is wonderful for portrait subjects, including dogs. Just find that open shade out in a beautiful outdoor setting and fire away.

Another part of practicing is getting feedback from other photographers. Join a club in your area, or better yet, get involved with your local affiliate of Professional Photographers of America. Usually once a month, a PPA group will host a print competition where you can submit work you've done for critique and scoring. It's a valuable way to learn what is working in your image-making and what might need to be refined.

There are tons of online groups that offer tutorials, e-courses, and forums for discussions about photography. I began my journey in an online forum many years ago, and I learned a tremendous amount about both the technical side of the craft and the business side. The forums proved to be an invaluable resource in my journey to becoming a pro.

MY GEAR AND METHOD

My equipment isn't complicated. I find that for white backdrop photography, simple is best. My favorite toy is a creation from our friends at Lastolite. It's called the Hi-Lite, and it has made my job so much easier. It's basically a giant retractable tent of light behind the subject. The portability of this light tent is terrific, being that I shoot on location several times a month. It folds down like a reflector and is put into a large circular carrying case with an arm strap.

My gear setup is as follows:

1. I place a light so it will shoot inside the unzipped Hi-Lite backdrop.
2. I meter the Hi-Lite for backlight at f/16 with my Sekonic meter.
3. I meter the softbox main light up front at f/8.
4. I place a Larson silver reflector on the other side of the Hi-Lite.

I am fearless when working with white dogs on a white high key backdrop. I actually like the crispness of this combo and will make sure the texture of their fur is captured well. I don't, however, enjoy capturing black dogs on black backgrounds, although you could light up their fur with a hair light above the backdrop.

For sessions on location outside, I like to have a shutter speed that is at least $^1/_{500}$ because dogs can move pretty quickly, and I don't want to have blur.

I set the meter for the shutter speed I desire and meter the dog's face for what aperture I should set my camera to. A wide aperture like f/2.8 is wonderful for blurring the background

and really makes the dog stand out, but it is very important that the eyes are clear, which can be difficult with a moving dog. The old adage "f/8 and be there" is one that can work with on-location dog photography. Dogs smell lots of things outdoors and are constantly moving. You don't want to end up with a batch of blurry fur-ball images to show your client.

Avoid direct sunlight. This is best accomplished by shooting one hour before the sun comes up or one hour before it goes down. Because few of us want to be out there with clients at 5:00AM, the "before sunset" sessions frequently become a staple for me in the summer. In the Pacific Northwest, we can have unpredictable, soggy weather for the better part of the year, and I find my outdoor sessions typically occur from May through early October. I use the sloppy weather months to shoot indoors. You might live in a warm place (I'm envious) and be able to shoot outside year-round. Perhaps just shooting outside is something you would like to do.

Beach portrait sessions are a great thing for dogs as they seem to truly be in their element on the sand. A drawback to that, of course, is the danger of getting sand in your lens or camera parts. I hold mine high above my head when a running dog is coming at me.

If you do have an outdoor session in the peak hours of overhead sun, be sure to find some open shade, like under a tree or an overhang. A reflector is essential for this type of lighting, as you'll want to bounce the light from outside the shaded area into the dog's face. Catchlights (those beautiful little sparkles in the eyes) are

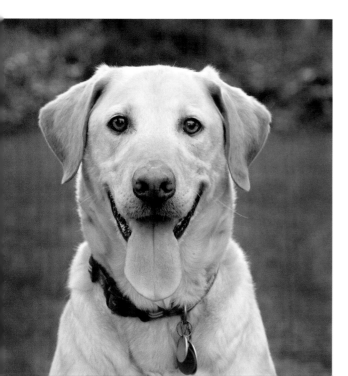

This image was captured at twilight using one silver reflector for catchlights.

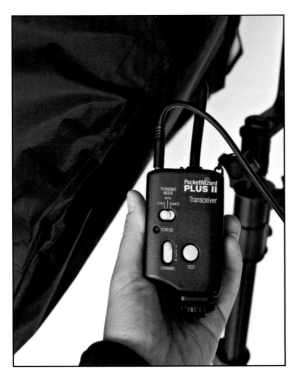

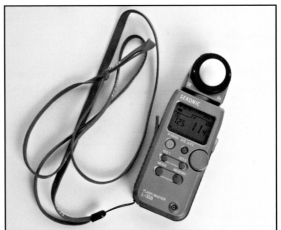

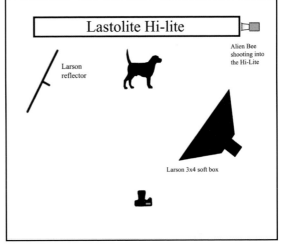

Left—A PocketWizard wireless remote is the industry standard. **Right**—Here's the trusty light meter that has traveled in my bag for years. **Bottom**—Here's a typical LBI dog studio portrait setup.

important for any subject to appear alive and well. Without them there is a danger of looking like an opossum! Not a good selling point. Be careful with dogs with dark fur. They can get "lost" in a shaded image and are best photographed against lighter-toned backdrops.

When working with a dog it is a good idea to shoot from different levels and perspectives. During a session, I always dress in clothes I can get on the ground in. Frequently my favorite image will be the one where the dog looks larger than life because my lens is slightly under him. I also find it fun to shoot at different angles, whether it's indoors or outdoors.

Suffice it to say, I never (never, never, never—did I say "never"?) use on-camera flash. It's just not my thing. If I use strobe lighting outdoors, the light will typically be a Nikon flash unit that I attach to a light stand with a small softbox on it.

I meter the dog's face with the desired aperture and allow the meter to tell me what shutter speed to use. This type of lighting can be handy

Top and bottom—These images were captured at twilight with a shutter speed of $^1/_{1000}$ to freeze the dog's expression in the portrait.

for a dramatic look because a higher shutter speed will darken the background and leave the subject's face illuminated beautifully.

POSTPRODUCTION

When you have finished your session, you will want to download and burn DVDs of your images for safety. For me, DVDs are necessary because the files are so huge. I shoot in RAW format only, and I recommend that you do as well. Shooting in RAW gives you all the image information possible in a digital file, information that you lose with TIFF or JPEG. With Adobe Bridge (the software I use to process RAW files), you acquire greater latitude in adjusting exposure, sharpness, and white balance. There are files that I have salvaged that I didn't think were salvageable when I loaded them into Bridge. It

really is worth the added storage hassle of having such massive files.

After processing the select images I want to show the client, I retouch them in Photoshop. I have many photographer friends who swear by Lightroom because of the sheer efficiency of processing many files at once, but I personally haven't used it. I like the system I have in place with Photoshop, and it's comfortable for me at this point in my career.

In postproduction, I typically crop and do basic edits on all the images to be shown, and do "artwork" (more extensive editing) on about six to ten images. I'm not interested in spending hours at the computer editing images I'm not even sure my client will purchase. There is plenty of time later to be meticulous when working on images they've ordered. Basic edits I like to do

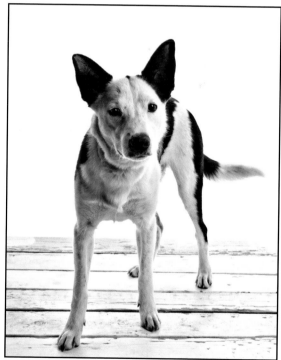

Leash be gone!

Top and bottom—In the Northwest, beach shoots are usually reserved for mid-summer . . . and there is still cloud cover during the day! **Facing page**—I like shooting straight down into the snout of a dog. It's a comical angle for capturing personality.

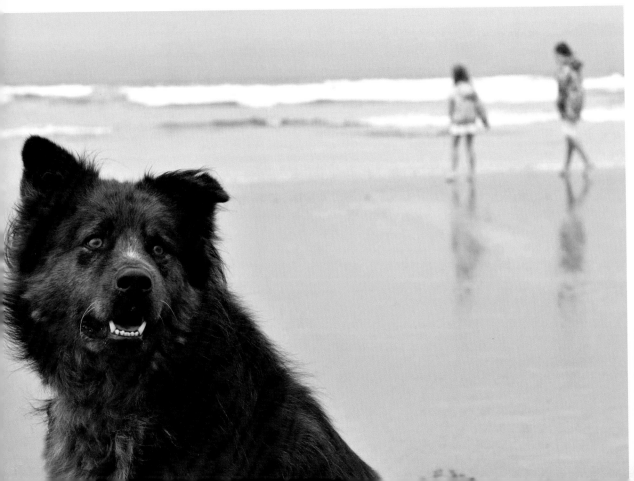

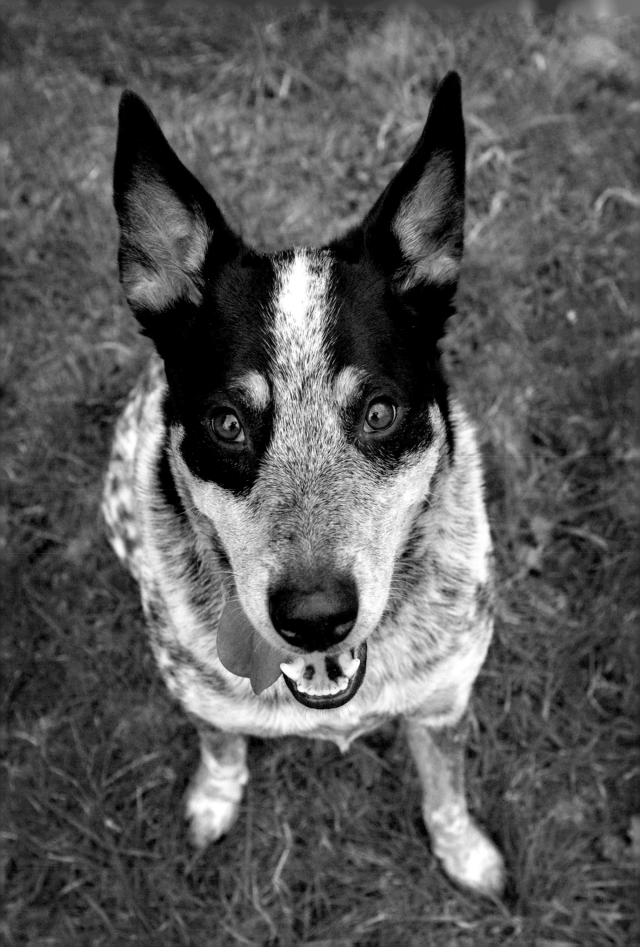

Eyes in the top third →

Lead lines from feet to eyes.

Top—The Rule of Thirds. **Bottom**—Real or implied lines in the pose can help draw the viewer's eye through the portrait. Here, the dog's legs draw the gaze to the eyes, the focal point of the portrait.

are bringing out the texture in the dog's fur with a bit of sharpening and smoothing the subject's skin using the healing brush and a smoothing action. I like to use actions when getting creative with a set of portraits. Kevin Kubota's Action Paks and Formula One actions are among my favorites.

I always try to aim for good image composition in-camera when taking an image. It is also nice to have the composition aided by Photoshop through cropping using the Rule of Thirds—a compositional rule of thumb that states that an image should be imagined as divided into nine equal parts by two equally spaced horizontal lines and two equally-spaced vertical lines, and that important compositional elements should be placed along these lines or at their intersections.

Leading lines and diagonals are useful tools in drawing the viewer's attention to one or more intended subjects or a single focal point.

DOGS AND THEIR SESSION BEHAVIOR

I find the technical part of photographing dogs to be pretty straightforward. Getting the dog to do what you want, however, is not. This process is more complicated and requires some strategy.

Shy dogs need a bit of time to get adjusted. As I mentioned in the chapter about consultations, these dogs benefit from meeting me (smelling me too!) before the session day. They also respond well when you get down low on the ground and do not engage, just let them sniff around the studio. Even after daily cleaning, there are still so many smells in my studio that I can completely understand how it would be overwhelming for a dog. My own Beagle, the super-nose breed, can't sit still in the studio. There are way too many smells for her hound nose to handle! After about ten to fifteen minutes of allowing an apprehensive dog to adjust, I will ask the owner to bring a treat on the backdrop.

Sometimes taking images of the owner and their dog together first is the way to go. The popping of the strobe lights is less frightening when the dog has his or her owner there to snuggle with. If all else fails and we're not able to get the dog to sit still, we will resort to either shooting the session outside, weather permitting, or putting a leash on the dog and removing it using Photoshop.

Luckily, I have not had an incident with an aggressive dog. I did, however, almost have my teeth knocked out by a very excited pit bull who saw that I was down on his level. I'm pretty sure he was heading for a kiss, but it ended up being a head-butt. I have been working on my reflexes in studio situations like this so that I don't walk away toothless.

SHOOTING SPACE

We've already talked about choosing a style of dog portraiture. Obviously the setting for hunting dog images is going to be vastly different than a sleek white backdrop studio setup. Since we've been going the boutique route up to this point, I'm going to cover how I do things, and you can adjust them to fit your own style.

I find that shooting in a smaller space works wonders when working with dogs. I actually found this out by accident. My old studio was kind of bowling alley-esque in that it was long and narrow. It was long enough for dogs to take off from the backdrop—escape artists on the run from my camera! It was challenging, to say the least. Fast forward to a move to a smaller shoot-

ing space (about a third the size of the old space) and you'll see me having fewer problems keeping my canine friends in front of my lights. When there's nowhere to go, dogs naturally stay in one spot, especially if there are treats involved. Believe me, at LBI there are always treats involved for dogs and humans.

I ask the owner to be the bearer of treats as we try to get the dog to perform for my camera. I ask them to stand on the opposite side of the softbox, face the dog (their backside facing me), and hold the treat high in the air. In the case of a dog that continually jumps off the backdrop, either because they're excited or they don't like the feel of it under their paws, I reassure the client that we will put them on the backdrop as many times as we need to in order to capture great images. If the dog owner is feeling stressed about behavior exhibited by their pet, the dog can pick up on it and become even more anxious. I make it very clear that we will do whatever it takes (however long it takes) to get great shots. This usually relaxes both human and animal and allows a little bit of fun to come into the session, especially if the dog is jumping all over the place.

This handy setup can go anywhere with you on a photo shoot. I frequently take it all apart and travel with it in my suitcase.

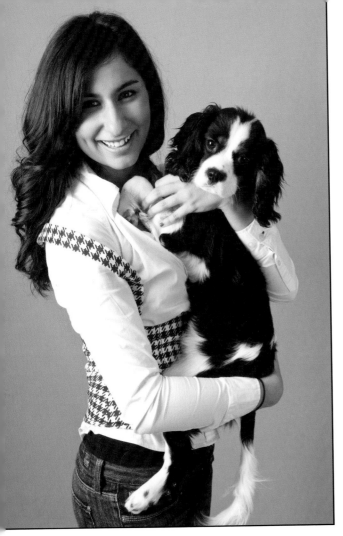

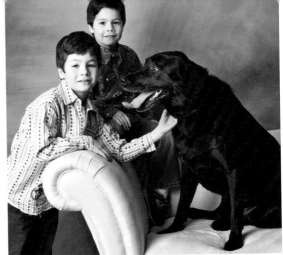

Left and right—Starting with images of the dogs with their owners is a good idea.

Furniture can be your friend when you are working with dogs who won't sit still. I've only had a couple of dogs who won't jump on the couch or lounge chairs I have in the studio. Sometimes just the feel of sitting on something familiar will allow them to relax. (It's funny how so many of our dog clients are allowed to jump on furniture at home!) I also like the look of a client snuggling with their dog on a big couch—it looks natural and sweet, and the animal just seems happier in this type of setting.

I'm shooting on colored backdrops less and less these days, as I'm finding my white back-drop style is more defining for our studio. I do, however, like to use them when I know the colors will suit a client's home well. I use a warm-toned backdrop for folks with warm-toned décor (reds, browns, yellows). They tend to gravitate toward these images on my web site and ask for this backdrop specifically.

ASSISTANTS

I find that the dog owner is the only assistant I need in most scenarios, but for fund-raisers with lots of dogs coming and going, I like to have at least one other set of hands to help out. Having the owner chasing one dog and the assistant chasing another can greatly increase your odds of getting shots of the two of them together.

An assistant can be an intern, a dog-loving friend, or a paid employee, but each will need to be trained before they jump into this adventure with you. Where to stand is very important because, naturally, you need all light sources to be free and clear of bodies. I always have my assistants lead the dog around "like a horse" with a treat so that they are facing me and the assistant

ends up between the main light and me. Dangling Milk Bones above their heads will give you plenty of "dogs who look up" images, but to capture that coveted "dog looking right in your lens" shot, you'll need to have your assistant bring the treat down for a couple of seconds to that sweet spot where they are looking straight forward, but can't reach the treat. I always have the assistant give the dog the treat after I capture a few images so he or she doesn't think we're teasing and lose interest. If an owner wants an image of their dog jumping, I have the assistant dangle the treat up high and ask them to jump. Nine times out of ten, we can capture a fun series of images in which they're jumping in different directions.

Photographing owners on a sofa or a comfortable chair with their dogs works well too. Everyone seems a bit more relaxed and the dog feels safe.

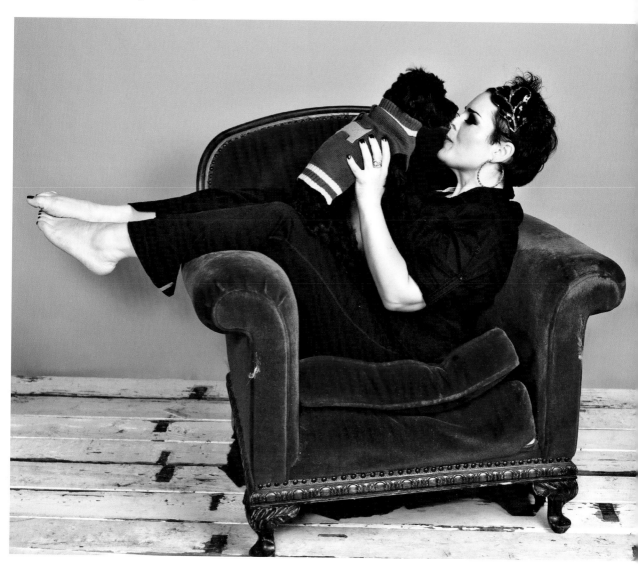

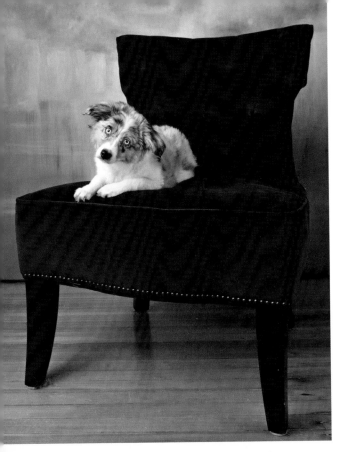

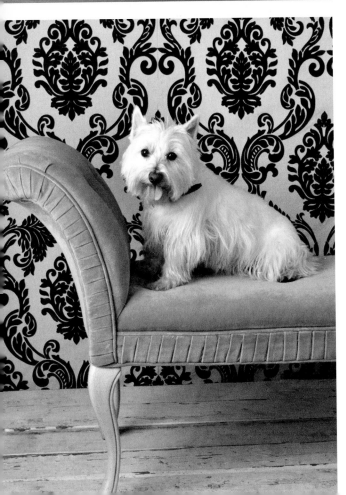

When I do sessions at dog daycares, I frequently do not have the owner present. This can be a good thing because the dog isn't distracted and hopefully will perform the requested tasks for treats. Yet, sometimes, the dog's owner is the best assistant you could ask for. Because this person is the one who trained them (not to mention the person they love most in the world), dogs who won't perform for you might pose for their owner.

Another great reason to have the owner present is that he or she can be used as a prop. Dogs who won't sit still for face shots usually respond well when placed on the owner's shoulder (the human's back is to your camera), and you can capture some terrific up-close-and-personal portraits, as well as some images of the dog and owner enjoying some snuggle time.

One of my favorite images of all time is Bogey, our Great Dane muse, licking his owner with his giant tongue. This might seem gross for some, but for the owner, this image made her laugh and she purchased it in a large print. I liked the image so much I used it on my business card.

Whenever I have the chance to talk with a dog owner in a pre-session consultation, I always suggest clothing they could wear if they want to be in the images. More often than not, the owner will say, "I don't want to be in these pictures. My dog is far more photogenic than me." But I still insist that we may need to use them as a prop. I suggest that they wear a white or dark-colored shirt, depending on the color of the dog. More

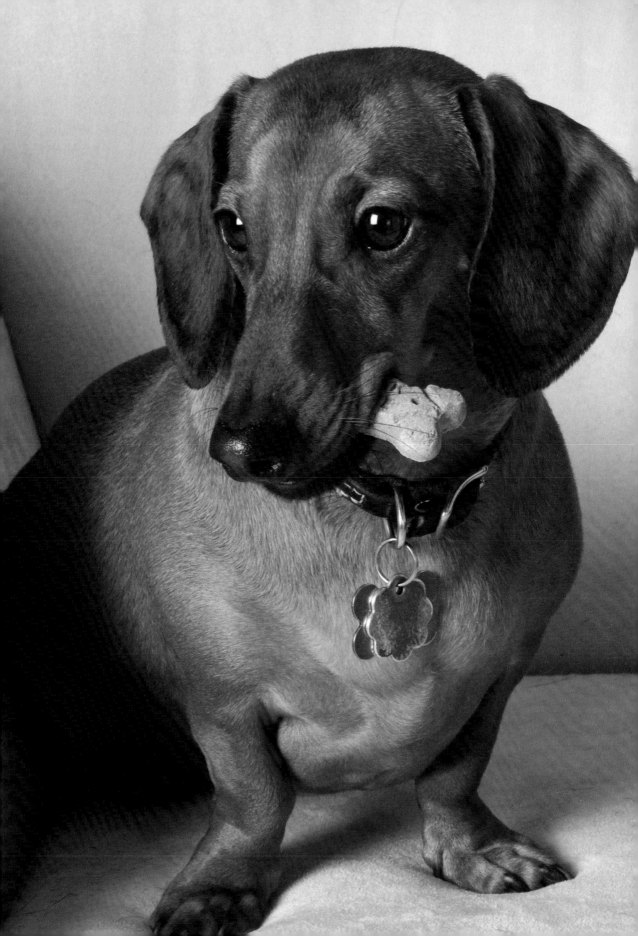

Left—When positioning a light for a shot like this, it's important that catchlights appear in the dog's eyes. Placing your main light at a 90 degree angle will accomplish this. **Right**—People can serve as props.

times than not, these clients end up ordering the image of them interacting with their dog. These portraits show how special the relationship is.

A TYPICAL STUDIO SESSION

I usually start things out with the owner and the dog together so that the dog feels safe and relaxed. They can sit together on the floor or the owner can crouch down behind the dog with arms wrapped about him or her. Lounging on a couch is great for shots, as is standing with the dog between the person's shoes. That image has become a signature shot for us.

Once the dog seems comfortable, I move on to photographing the dog sitting and lying down. I also like to have the animal's back to me and the face coming at me over the shoulder. This works with the assistant facing the dog by the backdrop dangling a treat and me giving a kitten mew so that the dog (hopefully) turns just his head. It's a nice look, and it's an image that clients always order.

The next set of images involves tricks, jumping, love affairs with toys, etc. It really depends on the dog and their interest in moving around the space.

Bulldogs are a classic example of dogs that just lie there with fabulous expressions on their faces. Not a ton of movement going on. I love Bulldogs! I've found them to be incredibly easy (and fun) to capture.

Our last part involves photographing the "dog parts" for future wall collages. I capture the feet, full face, nose, tail, ridge of fur on the back, etc. These images are also fun to put on custom cards in squares. We call these collages A Sum of Its Parts and show examples in the studio. There have been clients who schedule sessions with this specific collage idea in mind for their walls at home.

SQUEAKERS, BALLS, AND SOUNDS

Dogs respond to sounds that are not in their everyday environment. They love squeaky toys

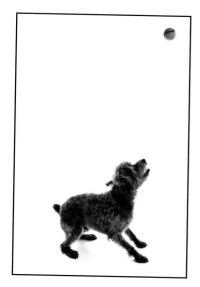

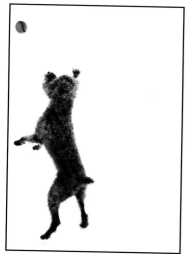

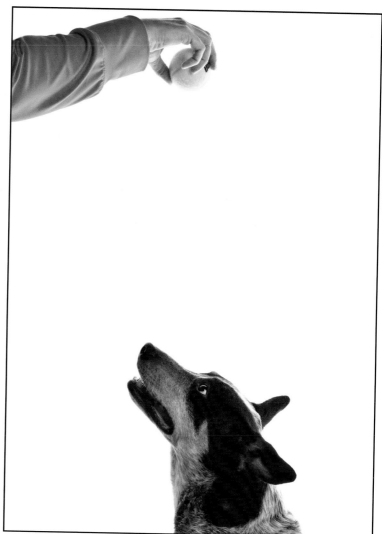

Top and bottom left—When working with a bouncing ball in a small studio space, I ask the owner to make sure the ball doesn't go too far or bounce too high. **Top right**—The owners of ball-obsessed dogs always love this shot. The complete focus is a crowd-pleaser. **Bottom right**—Tug-of-war on a slippery backdrop can be tricky, but if the dog has a firm grip on the toy, it makes for a fun shot.

Top and bottom left—Bulldogs are my hands-down favorite breed to photograph in the studio. They're often a blob on the floor with wonderfully expressive eyes. **Right**—I always have Milk Bones on hand, just in case I have a dog who is extremely talented.

personal favorite is a mewing kitten sound I've perfected over the years. This is great for getting a nervous dog to relax and perk up their ears. Dog owners always prefer images where their dog looks relaxed or curious, hence the perked ears. Like I said in a previous chapter, images of dogs with ears flattened on the head shouldn't even be shown to clients, as this shows how stressed the dog is in a studio environment. Unless, of course, the dog's ears are always down and there's just no way around it.

Tennis balls are great for jumping or action shots outside, but they are not the best for getting dogs to sit still with a curious face. Balls mean playtime to dogs, which is why they're best used in an outdoor session. Years ago I had a couple of ball-obsessed Golden Retrievers rip my studio apart while chasing down tennis balls.

that have unusual sounds. This may be your ace-in-the-hole for getting their attention. My

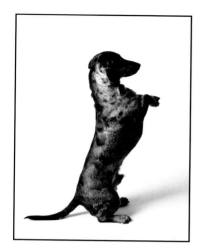

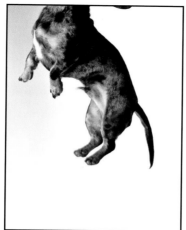

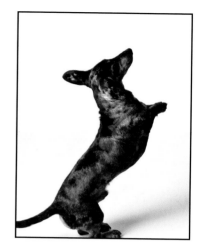

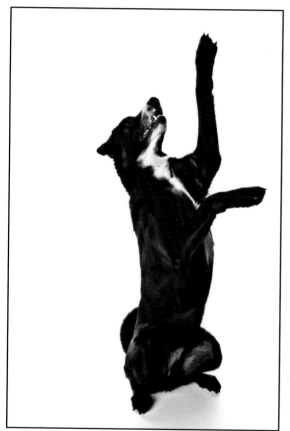

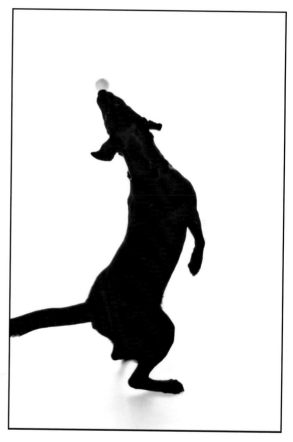

Top row—Frodo's owner was so delighted with these jumping images. This is his personality in a nutshell. **Bottom left**—It's a bit tricky to get a pure, non-blurry image of a jumping dog when using strobe lights in the studio. The shutter speed maxes out at $\frac{1}{200}$, and that's often too slow for a moving target. If you have a super-fast dog, heading outside to capture the images is best. **Bottom right**—This dog was pretty much game for anything. The high-fives were flying during this session, and the owner was thrilled to get this shot. He ordered a huge print of this image, to be displayed at his business.

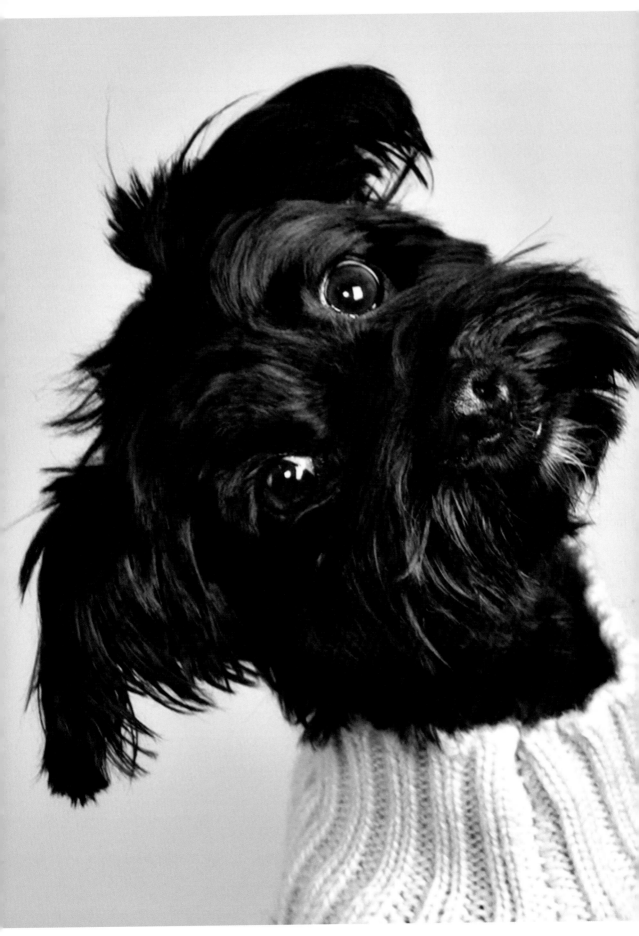

Facing page—Schepps was actually sitting on his owner's shoulder, but I cropped the owner out of the image and focused on the dog's precious face. **Top and bottom**—A dog's ears always tell me what it's feeling during the session. I try to capture images with the ears in various positions so the owner can choose the images that best reflect the dog's personality.

It was a lesson I learned early, so now I hide them, unless a highly trained dog came in and the owner requested the presence of a ball.

TREATS

I always ask the owner if the treats we provide at the studio are suitable for their dog. Some dogs have allergies, are on diets, or simply don't like treats. We have a variety in jars for the owners to choose from.

When asking a dog to perform for a treat, my assistant usually gives the dog a tiny taste to help them know what they're working for. The session might require a lot of treat rewards, so we use very small broken-off portions for motivation.

Ask an owner ahead of time if their dog is treat-motivated or will respond to squeakers. This is great information to have when going into a session.

TRICKS

Dogs that do tricks are particularly fun to work with. Some of my favorites involve nose balancing acts with treats, tennis ball antics, and loving on fluffy toys. I am also fond of the "Bang! You're dead" series of images where dogs will lie down with their paws splayed to the sides.

I always get the tricks captured closer to the beginning of the session, as the clients usually

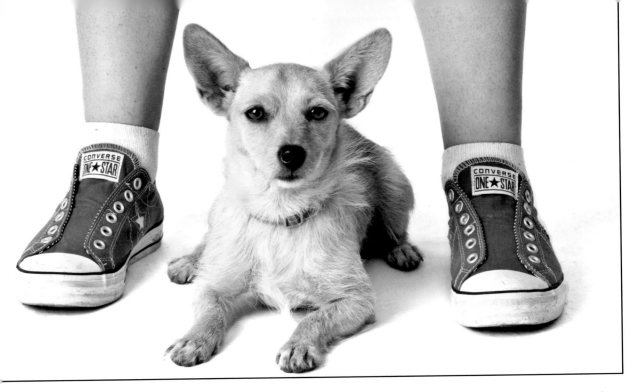

Above and facing page—We at LBI have a foot fetish. The pose helps the dog stay in place and also shows the relationship.

want these for posterity and I don't want to tucker out Rover before he can perform them. I keep lots of toys and treats in glass jars (to eliminate smells) up high so that they won't go hunting for them when they're supposed to be posing for me.

DOGS WHO WON'T SIT ON THE BACKDROP

As I've mentioned, some dogs find that seamless paper or canvas feels very foreign and strange under their paws. It's not a happy, comfortable place for such dogs to linger. I find that dogs feel safer when their owners are standing next to them. Many dogs (especially trained dogs) feel secure on a leash because they know what is expected of them. So if a dog refuses to stand on the backdrop, having a leash-holding owner stand on the farthest side of the paper or canvas might help you get the job done. Just ask the owner to pull the leash taut so that it doesn't fall on the dog's fur. Fixing things in Photoshop (e.g., removing leashes) is not something I like doing, but when you've got thirty minutes to capture a dog, sometimes a little extra post-production work is worth doing.

With dogs who run every time your lights fire or flee from the backdrop even when they're on a leash, it may be time to reschedule the session for another day at an outdoor location. I've worked with dogs who just are not themselves in a studio setting. Big dogs, in particular, seem to do much better running outside or lounging on the couch at home.

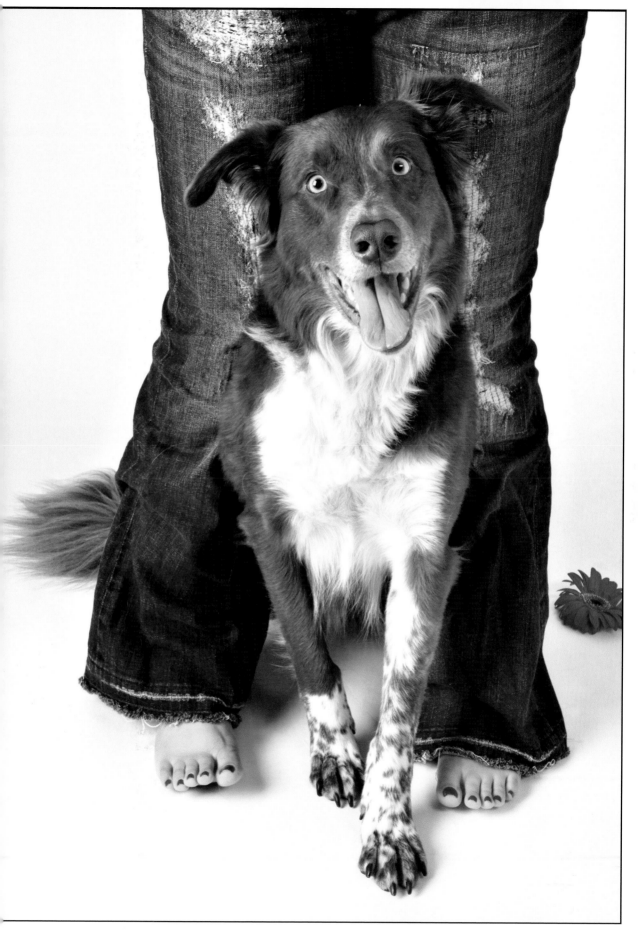

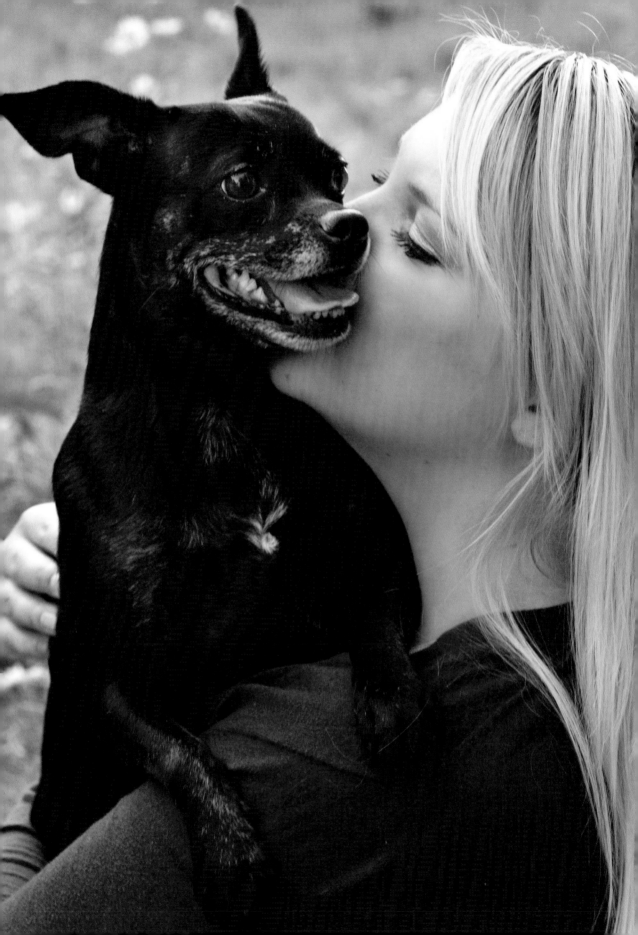

6. Dog-u-mentary Sessions: Dogs on Location

The average dog is a nicer person than the average person.—Andy Rooney

At LBI, we offer several on-location session experiences. These sessions can be held anywhere the dog feels at home: a dog park, beach, urban landscape, or even the owner's home. Inevitably, the dog's personality will shine through in a natural environment.

DOG PARKS

Dog parks need to be scouted before you bring clients to them for a session. Obviously, you won't want other dogs in your clients' images, so an early-morning session is recommended. You also need to check if a permit is required to photograph at a park, especially if it's a state park. Clients who have acreage of their own are a dream because you eliminate all of these potential problems of an outdoor park setting. I offer my own property to my clients for sessions. Our acreage is very rural and has lots of different settings (flower fields, forests, barns, and mountains in the distance) and is a lure for city-dwelling clients. It is an environment where dogs run wild and free—great for action shots of dogs (and dog owners) having a good time.

Facing page and right—Dogs are at home outdoors. This subject appears in his element in his owner's arms and hunkered down in the grass.

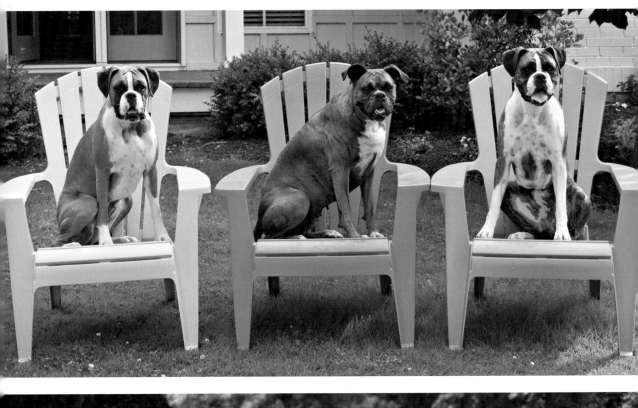

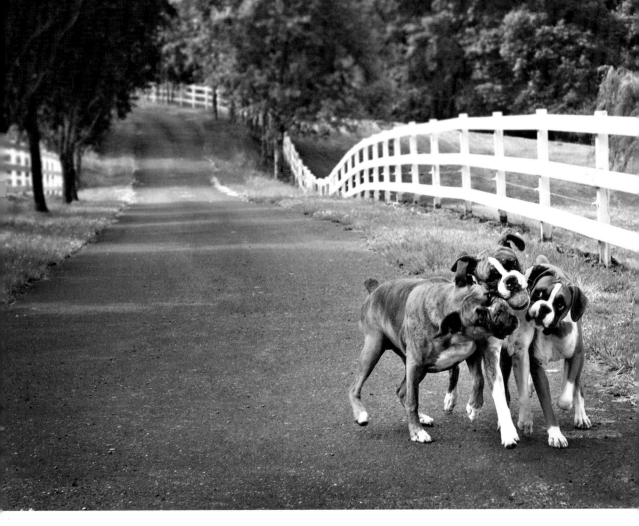

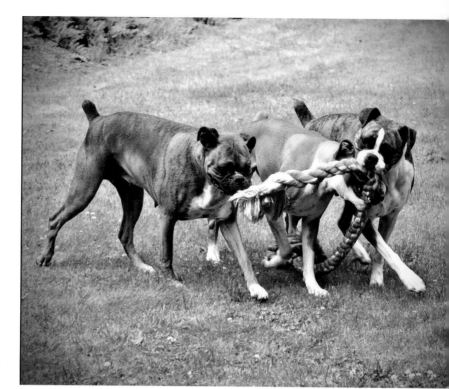

Facing page—I shot this series on an overcast morning. Bright sunlight makes for squinting subjects, and owners want to see their dogs' eyes. The secret here was to bribe the dogs with treats (to keep them on the chairs) and a rope toy that they all loved (see the top-right image). **Top and bottom**—A trio of dogs will be best photographed outdoors where they can run and be wild. These dogs would have wreaked havoc in the studio!

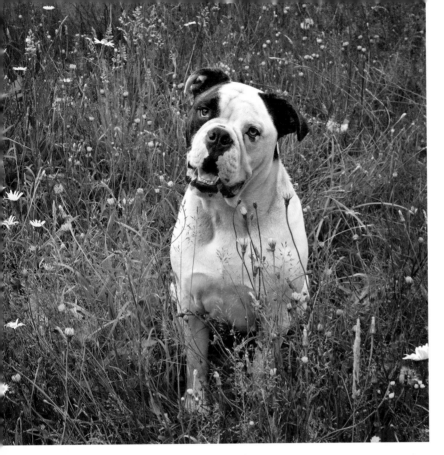

This dog responded well to my mewing kitten sound. The cocked head makes for a nice image anywhere, but especially when surrounded by daisies.

I love images of small dogs in the grass at their owner's feet. This was captured in a big field on an overcast day.

THE BEACH

I love shooting at the beach in the spot where a dog's reflection is clearly visible in the sand. It's dangerously close to the water, so I always ask the owner if it's okay if the dog gets wet. Some big dogs get a not-so-attractive crimped hair-do when wet.

Make sure that it isn't a beach-party foul to have the dog off leash when capturing their portraits. Another obvious thing to look out for at the beach is sand in your camera. Sadly, I've sent my camera to repair for granules in my zoom lens more than once.

Beach sessions are best done on overcast days, early in the morning, or an hour before sunset.

Top—I really like it when a small dog grabs a large stick to haul around on a beach shoot. It shows the "big dog personality" inside of the little dog. **Bottom**—I like to make sure there is some water showing behind a prancing dog when photographing a beach scene. It completes the scene.

To get those gorgeous catchlights in a dog's eyes when he or she is posing on the sand, I either have the owner hold up a reflector or I wear all white. Sometimes a white outfit is enough to reflect in a big dog's eyes.

As far as human clothing goes for these beach sessions, I prefer white shirts and jeans. It's a

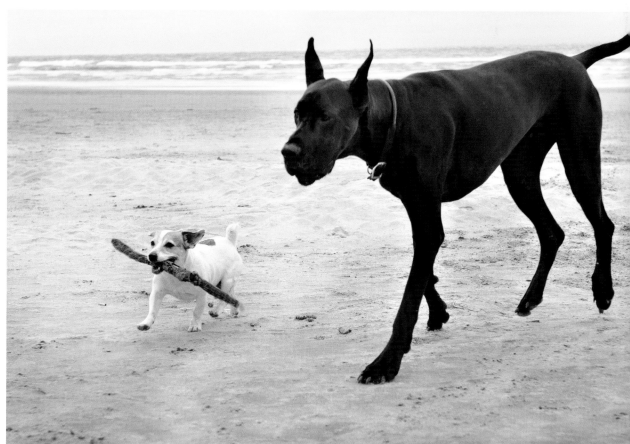

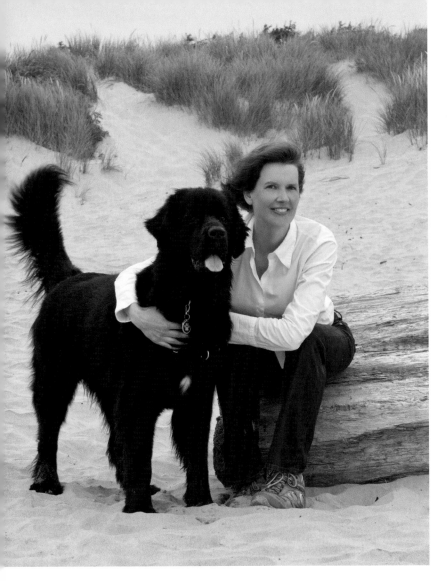

Left—Driftwood or beach logs are excellent posing spots for dogs or their owners. Including some beach grass in the background will add nice texture in the image. **Facing page**—Beach sessions are always conducted early in the morning when the sun is low in the sky and the beach is quiet. It's difficult to wrangle a dog you're working with when they're tangled up in other dogs' leashes.

fresh and clean look that doesn't distract the viewer's eye when looking at an image of a dog on the beach.

DOGS IN MOTION

When photographing running dogs, you've got to make sure your shutter speed is high. I try to stay at $^1/_{750}$ or higher when working with frolicking pooches. I wear jeans and boots so that I can get down on the ground and focus on them running toward me. Of course, I'm careful to jump up before they smash into my camera.

The tennis ball is your friend in this type of session. I have the dog owners throw it over and over again until I get the shot I'm

I try to stay at $^1/_{750}$ or higher when working with frolicking pooches.

When photographing dogs chasing balls, the shutter speed on your camera will need to be quite high. I like to meter the dog with a working shutter speed of $1/750$ second or higher to minimize blur.

looking for. Treats are also a good tool during outdoor sessions because at some point you will want them to stop and pose in the beautiful outdoor environment. I like to have the owners in these images, so talking to them about clothing ahead of time is essential. Jeans, solid-colored shirts (flannel is good), and neutral-toned shoes are best when shooting in a field or the woods.

Top—I like making the dog look like a connoisseur of art in a fancy hotel or museum. **Bottom**—Dogs who sit at chairs in restaurants are hilarious. I've had some funny interactions with patrons outside cafes when posing a dog at a table.

THE BIG CITY

When working with city-slicker furry friends, I am going for a totally different feel. I frequently treat the session like a magazine shoot. I ask the owner to be in these images, and I've had great luck with my city clients dressing the part. I encourage hats, bright colors, and "bling" for the dog. There's the "woman-sitting-at-a-café-with-the-dog-in-her-purse" image. There's the "sharply-dressed-couple-walking-their-dog-down-a-bustling-street" image. There's even the "dog-in-the-basket-of-a-bicycle-riding-city-dweller" image.

Again, streets without crowds are better to work with, so I try to begin these sessions just after everyone has gotten to work on a weekday, or in the early evening when everyone has gone home. I always work with an assistant during city sessions. She is helpful in reflector-holding, styling the image if need be, and holding the ladder when I need to get up high. Yes, I have hauled a ladder into downtown Portland, and it was totally worth it!

DAY IN THE LIFE SESSIONS

One of our most popular Dog-u-mentary sessions is done in the dog's home. I spend three to four hours hanging out with the dog (with my camera at the ready, of course) in all of their favorite spots. Typically we lounge on the front porch, on the couch, by their dog dish, in the yard looking for squirrels, and even in the

Top and bottom left—Many dogs are at home on their owner's bed. Poodles, in particular, look very regal in fancy bedding. This client's French-inspired home matches her dogs perfectly. **Right**—Photographing an owner with her dogs in a dark hallway requires a main light set at a 90 degree angle and a reflector on the other side.

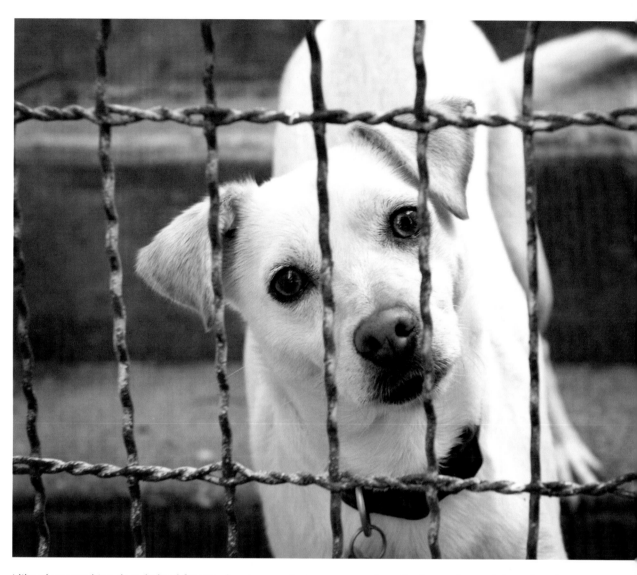

I like photographing dogs behind fences when I can make images away from the fence afterward. I get that view of the dog that the mail carrier gets.

owner's bed (me sitting on a chair, not in the sheets). The reason I spend so much time in this type of session is that the more time I spend in the dog's home, the more "normal" it seems for me to be there from the dog's point of view. I want the dog to do what he or she always does without anxiety. Paying a friendly visit a few days before the session is a good investment of time.

Not being a stranger on session day can be very helpful when it comes to setting up your gear.

I try to avoid using strobes or flashes when in the client's home. However, there are times when the shooting areas in the house are dark and additional illumination is needed. In these situations I try to use the least obtrusive method of lighting the room. I'll either bounce a bare

Facing page—Dark stairways also require a main light and a reflector for maximum light. The trick is getting the dog to stay in one spot when the light fires. Treats work well in helping you earn the dog's cooperation.
Top—Doorways are one of my favorite places to photograph owners sharing a moment with their canine friend. The world outside is a pleasing backdrop.
Bottom—This image was captured on a very sunny afternoon. Bogey, the Great Dane, managed to keep his eyes open when I clicked the shutter. He loves bounding through the sunflowers in his owner's yard, and the owner really wanted a shot with him in the bushes. Success!

flash (on a stand) off the ceiling via remote or fire a small softbox light (also via remote) as far away from the dog as possible. A silver reflector is a great tool for adding light when shooting portraits outdoors.

The main goal of this kind of session is a Day in the Life coffee-table book for the client. I actually sell this experience as a package (session fee and book purchase together). Each section of the book tells a story about the dog's life at home. I try to include special elements, like relationships with toys, snuggle time with the owner, and meal time rituals. I put all of the images together with text in an artistic way—every client book is unique—and then upload it to my lab, White House Custom Color.

It's not uncommon for me to do a Day in the Life session for a client who has already had a studio session. During the ordering session for the studio images, I make sure to show clients sample coffee-table books and offer this home session as a possibility for the future. The product speaks for itself, and many of my best clients have participated in this experience. Even though it's a hefty investment, they feel it is worth it because

Giorgi and Asia

C'est beau la

Being Daisy.

Above—Each Day in the Life album is customized for each client. No two albums made by LBI have ever been the same. **Facing page**—*(top left)* This cat was held in place by the owner's ankles. In two seconds, she was off and running, but we got the shot. *(top right)* Holding a piece of string above the cat's head can sometimes produce good results, like it did with this feline friend. *(bottom)* I have to admit that I like photographing fat cats best because you can fill up the frame with their large size. Here, I chose to leave a lot of white space in the frame, allowing the cat to take up the width of the lower third of the frame. A composition like this communicates something different than showing the whole cat.

it captures their dog's personality in such a comprehensive and creative way.

CATS

It seems odd to even mention the word "cat" in a dog book, but inevitably at our studio, people ask us if we work with cats. I always say that I do. The reason for this? Having a reputation as an animal-friendly person (as in all animals) is a wonderful thing when one's studio is primarily pet-centered. Throwing in a cat

It seems odd to even mention the word "cat" in a dog book, but inevitably at our studio, people ask us if we work with cats.

Apparently, this bird spends a lot of time on this woman's head at home, so we didn't have too much trouble staging this image.

session once in a while is actually good for business. People who love their cat enough to bring them in for professional pictures usually know dog people. They may prove to be a great source for referrals.

Cats are not easy to work with, I will tell you that. "Sit," "stay," and holding treats above their heads do not pave the way to great cat images. Most of the time, I start by having the owner hold the cat on their shoulder (the client's back to the camera). You can get a nice close-up of the feline's face and beautiful eyes. I do have an assistant dangle some string above my head so that the subject looks in the direction of the camera.

Bringing out a couch or a comfortable chair is also a good idea when trying to get a cat to stay in one spot. I have the owner sit with them and pet their fur for a while and then ask them

to slowly get up and leave the furniture. Many times the cat will jump down immediately. It's important to tell the client that you will do this as many times as necessary to get some good images. I've had cat owners stress out a little that their cat won't stay put, but I am quick to let them know that I am capturing what they want through this process.

I've actually had some great cats in the studio and really enjoyed working with them. We always have cats at our annual fund-raiser, Paws . . . for a Cause, and the practice during the year is a good thing for me. This year we even photographed a bird or two—one of my favorite shots of the whole event this year was when the bird wouldn't come down off the woman's head.

7. The Sales Experience

You can say any fool thing to a dog and the dog will just give you this look that says "My gosh, you're right! I never would have thought of that!"—*Dave Barry*

A lot of photographers say that the sales experience begins in the camera room. I think for LBI, it begins in the first inquiry by phone or e-mail and also during the consultation. I always ask a potential client what their main goal is for the session experience. Is it a wall portrait series of their dog? Maybe an album? Possibly Christmas cards featuring their pet? I typically will give them a ballpark investment value for what they're looking for. For one thing, this information can deter clients whose budget might not be right for your studio's services. For another thing, it helps to avoid sticker shock in the sales room on ordering day.

PREPARING THE IMAGES

I mentioned that I try to err on the side of not showing too many images during ordering sessions. Dogs rarely change their expressions drastically, so the look on the canine face is pretty consistent. My image choices are based on the position of the dog and creative collages like A Sum of Its Parts or a series of images that tell a story.

Of course, when people are in the images, I make sure the owner looks terrific as well. The artwork is done to just a handful of the images, and the rest go through a basic set of actions to be client-ready. I burn a DVD of the edited

Buddy had a great personality, and this collage showed it off perfectly.

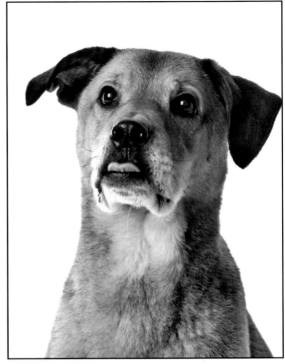

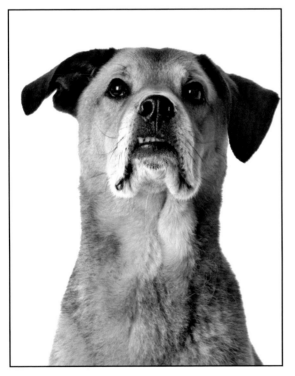

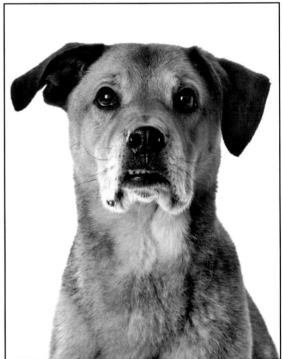

Even slight variations of expression on a dog yield a creative art piece.

Putting beach images together next to a larger collage shows a client how they decorate their home with their pooch's image.

images and place it in the client folder. The image files are then loaded onto the viewing room computer for the sales session.

THE ORDERING SESSION

We used to call this "the viewing," but it sounded like a funeral home event. We also realized that people need to know they'll be *ordering* their portraits as well as *viewing* them at this time.

Though many photographers shy away from sales and present their images online, we prefer face-to-face presentations.

IN-STUDIO PROJECTION

We've all heard that projecting your images can boost your sales by an incredible rate. I also have found this to be true. I sometimes chuckle to myself thinking about my old sales technique of lining up little 4x5-inch prints on a table for my clients to view (who usually put their reading glasses on). Times have changed for the better!

All our images have basic editing done to them, but digital "artwork" is done to my top ten or so favorite images. We project these onto a 12x7-foot screen about twelve feet from the

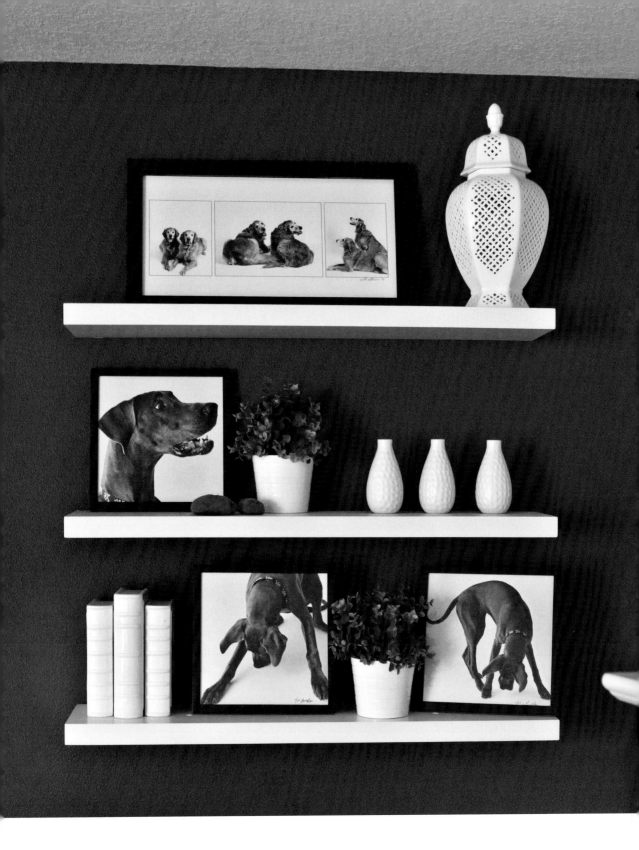

client using ProSelect software. In addition to this impressive display, we offer refreshments and soft music to enhance the sales experience. As I mentioned in a previous chapter, I like to include images I might have taken of the client's empty walls during an in-home portrait session. I load the wall photos into Photoshop and superimpose some of the images onto the wall image. This helps with suggestions about portrait size and grouping possibilities. It also solves the "I don't have anywhere to put large prints" problem.

I make sure that the client knows that all people responsible for financial decisions in the client's household need to be present at the ordering session. The dreaded "I need to talk this over with my spouse" must be avoided at all costs.

For clients who haven't had a home visit before the session or ordering appointment, I like to snail-mail them a card for recording wall measurements and ask them to bring it with them to the ordering session so that I can project that exact size on the screen.

Facing page—When I do place smaller pieces on a display wall, I put them in groups on shelves to show yet another way to showcase portraits. Not everyone is interested in large pieces. **Below**—Be sure to brush the hair out of the eyes of fluffy dogs so you can see their eyes sparkle.

LBI PRODUCTS IN THE STUDIO

We take great care in presenting our prints and special products in our studio space. The studio brand colors of moss green, black and chocolate brown carry through in everything we show our clients. In keeping with our brand, all of the display frames are black so that the images have a uniform look.

I've found that the best way to showcase the Dog as Art concept is to show wall collages in the studio in the form of 16x20 or 20x20-inch framed prints. We also offer a collage of prints within one frame. Some of our city-dwelling clients have limited wall space in their compact condos, but we still want them to feel that they can display a smaller piece of collage dog art. These folks are also good candidates for dog

Being armed with as much information about the clients' needs as possible is your biggest ally in boosting portrait sales.

albums, coffee-table books, silver image jewelry, and cases housing DVD slideshows, which are all displayed in a beautiful manner on our coffee table in front of them.

We also sell low-resolution images for Facebook use. I usually wrap up the session with this offer after the client has signed the copyright agreement, which asks them not to reproduce the images purchased. This protects me, as the creator of the images, and it is also a sales add-on with something they consider valuable. I actually found a very fun thing for dog owners on Facebook that allows you to create an account for your dog on a section called "Dog Book." My clients get a kick out of this and are excited to go sign up with their LBI images, which is great advertising for me in the dog community in our area.

FRAMING

We really want our clients to hang their portraits as soon as they get home. For this reason, I offer affordable framing. I realize they can go to a local craft store with a coupon and get this done, but I also know that busy schedules can keep someone from doing it sooner rather than later. I shudder at the thought of their dog art sitting in a box under the bed! Plus, it's a nice little add-on when the order is complete.

> We really want our clients to hang their portraits as soon as they get home. For this reason, I offer affordable framing.

We keep our frame choices very simple: black, chocolate brown, and white. Some have mats and some don't. I prefer that groups of prints (of dog faces, for example) remain mat-less, as it looks clean and simple, just like a lot of the décor in my clients' homes.

IN-HOME ORDERING SESSIONS

Although I believe projection is the best way to showcase the fine art I've created of my client's dog, sometimes it is difficult to persuade busy city slicker dog owners to jaunt over to my country studio, a 35- to 40-minute drive from town. They simply don't have time, and I don't want too much time to pass before they see the images. So, I've created a sort of traveling sales presentation to take to their homes.

There are three very good reasons that I would swap the impressive projected image experience for a home presentation on my laptop: (1) I can walk around their home and see all of the

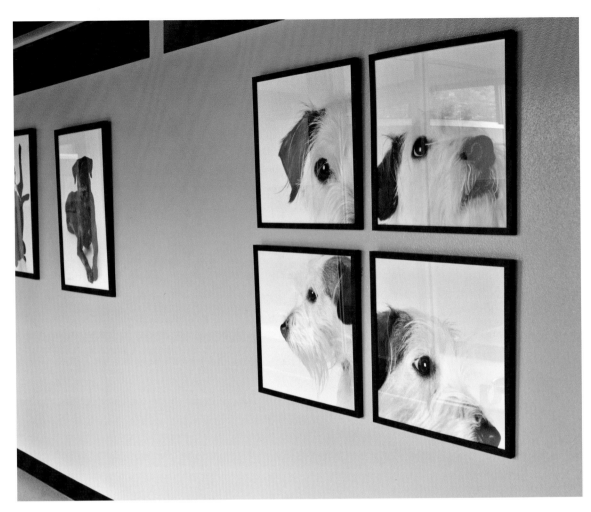

Bix is a rock star at this high-end daycare. It's my favorite installment to date.

fabulous wall space that is ripe for portrait hanging—and hold up samples! (2) Clients feel comfortable in their own homes and are relaxed about the sales experience. (3) I can usually schedule this type of ordering session quickly after the portrait session because it is more convenient for me to come to them.

My large traveling cases have been outfitted with the LBI special products, including prints from 16x20 to 20x20 inches and an array of coffee-table books. Each item is wrapped in black velvet cloth to convey the worth of such special portrait gems (remember, it's art we're selling here). I show each piece before we do our walkabout in the clients' home so that they can visualize what they might want to invest in. I especially love holding up the requested 11x14-inch print and showing the client that it really isn't a wall size—it's far too small for the space—and that a collage of images

I show each piece before we do our walkabout in the clients' home so that they can visualize what they might want to invest in.

or one large whopper print is the way to go. I believe that seeing is believing. Years ago during an ordering session, I showed a client a digital version of a large wall display I created of his dog. He wasn't sold on it and I didn't push it, but I loved it so much I printed each image as a 20x20 and displayed them at a dog daycare as an art installment.

The dog owner called me and said how impressed he was when he saw them on a tour of the daycare facility. He couldn't get over how impactful it was to see the display in person. I ended up going over to his house to measure his walls for the same display! Like I said, sometimes a Dog as Art display needs to be in front of your client for it to make the desired impact.

PRODUCT DELIVERY

I feel strongly that clients should experience your brand from start to finish in the portrait-making process. LBI clients receive their portraits in beautiful high-end packaging with lots of ribbon and tissue paper. The packaging materials go with our brand of black, chocolate brown, and moss green. We have taken to using silhouettes of dogs on many of our brochures and marketing materials and also include a silhouette image on our address labels. We take great care in packaging our framed portraits in bubble wrap and then in pretty black paper so that they arrive safely.

When clients have made a substantial investment in a wall collage display, I enjoy helping them hang their prints on the wall with

It's not uncommon to spend as much on the studio packaging as the printing of the images. Presentation is everything.

complimentary in-home delivery and installation. A nice perk in doing this is that I get to capture an image of the display for my blog and marketing materials, and if I'm lucky, receive a written testimonial from the client, who was pleased as punch that I came out to help them hang their prints. It's really fun to see their faces light up when you get the images up, especially when they're huge prints that greet you when you walk in the door. Those are my favorites!

For all of my city clients, I deliver orders in the same fashion. Frequently, many of my clients send their dogs to the same dog daycare, and I can do a massive drop-off of numerous orders at once. Sometimes, I deliver to their homes and/or send small orders in the mail. It's all about making it convenient for these busy people who have invested in the studio. This kind of customer service will be noticed and talked about at the local dog park or dog get-together, encouraging other dog owners to seek you out for some portrait art.

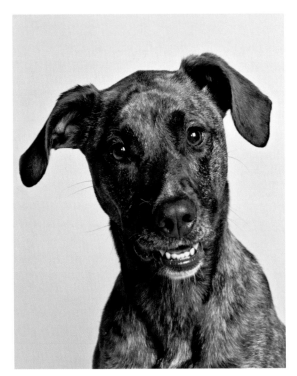 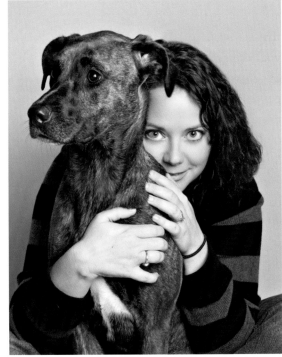

Creating some images that showcase the dog alone and some that show the bond between the owner and her dog can help you increase your sales and, ultimately, your profits.

8. Dog Charitable Work

I've seen a look in dogs' eyes, a quickly vanishing look of amazed contempt, and I am convinced that basically dogs think humans are nuts.—John Steinbeck

AUCTIONS

I cannot stress enough how important auctions are to your bottom line. Not only does it show that you are a business owner who cares about your community, it also puts your work in front of your target audience. My city is one of the biggest dog cities in the United States, as I've mentioned, and there are a lot of auctions throughout the year that focus on pet care. The Humane Society, animal shelters, and animal hospitals are great places to start to look for auctions in your community. Even if you don't have one right in your town, I'd be willing to bet that there is a shelter that does similar work. The best way to donate to an auction is to call the organization and ask for the name and contact information of the auction chairperson.

You will need to find out if they will have display space at the event for your framed images and informational materials. Ask the chairperson if you will be included in the silent or live auction. I have found that when I'm included in

a live auction, the display space is much larger because live auction items tend to go for quite a bit more. It's a chance for the whole audience to hear about your studio and potentially see your work up on a screen, rather than a select few seeing your display on a table during a silent auction.

When choosing your images for an auction display, pick your absolute favorites that highlight your shooting style. There will most likely be other animal photographers there, so try to

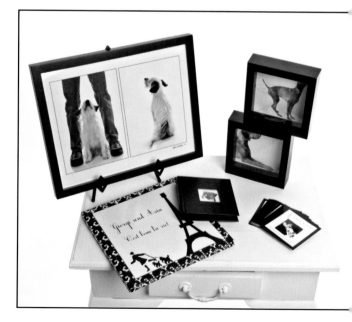

I like to display as many products as the space allows at auctions to show potential clients what we can do with a simple image of a dog.

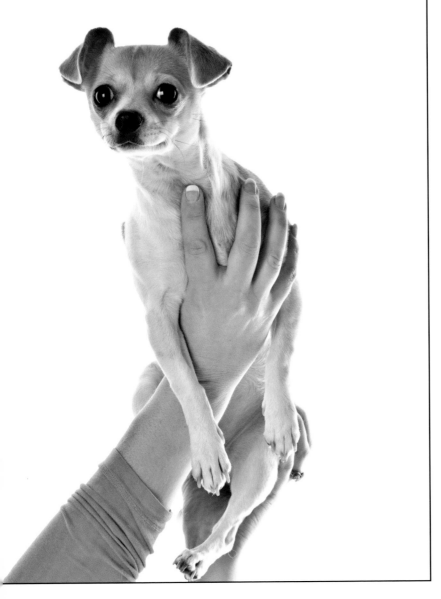

Tinley is a rock star Chi-weenie that belongs to my child's music teacher. She was a great supporter of LBI at the school auction and has referred numerous clients to our studio.

stand out the best that you can with unique and creative images and brochures. I generally deliver all display materials myself to the auction location the day before or day of the event. I've had some frames damaged and items lost when I placed this job in volunteers' hands. I also try to pick up the display right after the event so that my stuff doesn't get lost in the shuffle with the cleanup.

I think it's important to attend these events as well as donate to them. An auction is a wonderful place to make contacts in the dog community, meet dog owners who are checking out your display, and show the organization you care about their cause. Plus, you can write off the ticket, which can sometimes be a bit spendy.

I have a list of auctions that I donate to annually. We keep in contact with the chairperson

throughout the year and let them know that they can count on us to donate every year. I believe this creates loyalty to you, as a business owner. Perhaps in the future when an organization requires photographic services, your name will be the first to pop into their heads because of your charitable involvement with their organization. Being consistent and generous always pays off when donating to local charities and non-profits.

DONATING STUDIO TIME AND IMAGE USAGE

We find it very important to give back to charitable organizations throughout the year, not just at auction or during fund-raising time. We know that images are valuable when it comes to finding homes for pets in shelters. That is why we open our studio free of charge to dogs and cats that have been at the Humane Society for long periods of time and are desperate for homes.

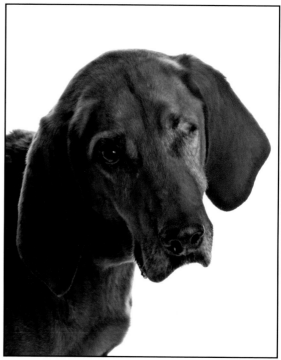

Top—This sweet dog needed a good image so that people would be willing to go to the shelter to get to know her. **Bottom**—Contemplative and serene shots are valuable to a dog owner too.

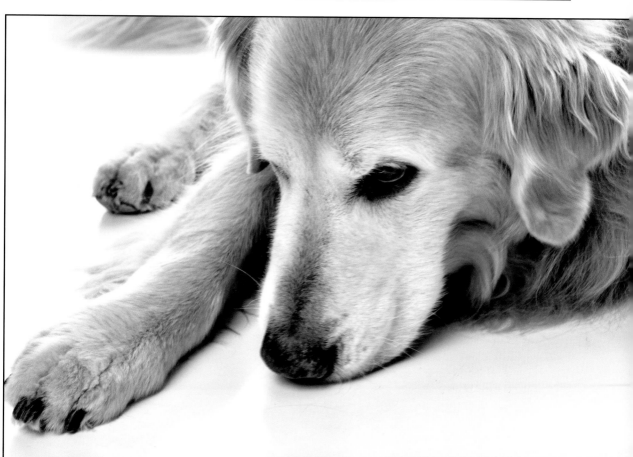

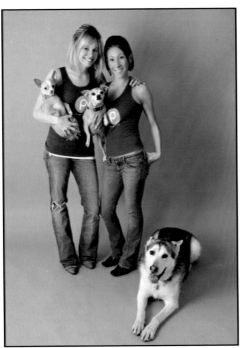 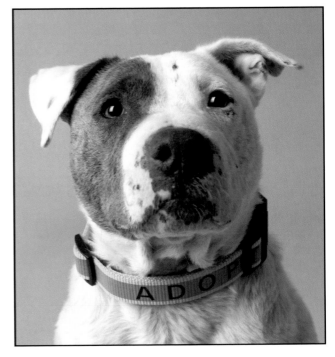

Top left and right—This high-profile no-kill shelter was very gracious about featuring our images with every PR opportunity that came along. **Bottom left**—Karli and Amy posed with their dogs for the bio page on their web site. **Bottom right**—Daisy is modeling a collar sold by The Pixie Project. Of course, we offered to take these portraits for them so that the images looked professional on their web site.

A shelter worker will contact us and schedule a studio appointment for such an animal and will frequently take them to be groomed beforehand. We want the dog or cat to look their best in the images, as these will hopefully entice people looking at the web site to go and see them in person. We send these images (with our logo, of course) to be uploaded to the shelter site as well as their Facebook page. We post them on our blog as well, hoping that a dog-loving client will be moved to visit them at the shelter. During the busy season at the studio (particularly holiday time), I like to schedule a few of these back to back on one day to maximize the opportunity to donate this time to the shelter.

We have also scheduled sessions specifically for a shelter's marketing campaign. The Pixie Project in Portland is an amazing facility with a terrific brand, and we catered these donated sessions to this brand. We photographed the staff and their animals, the gear that they sell in their retail section, as well as several shelter animals that would be featured on their site. We were so grateful to have huge poster versions of these images in their windows when *The Today Show* came and did a story on their success.

PAWS . . . FOR A CAUSE

Our big annual fund-raiser for the Humane Society here in our town is held every February. It's a

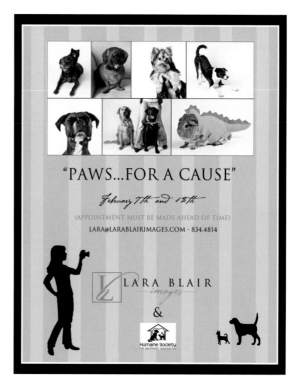

Left—I featured images of as many dogs as possible on year-two's brochure. I wanted people to see their dog on the brochure and show it to other people. **Right**—Every piece made for Paws . . . for a Cause is branded with LBI colors.

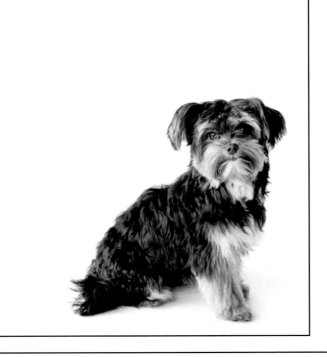

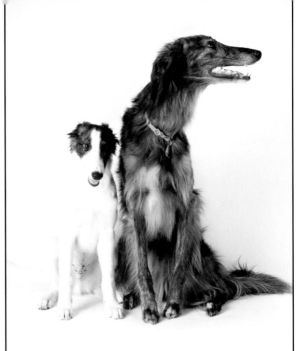

Top left—The setup is the same for each dog. The main light is placed at 90 degrees on one side, a reflector is placed on the other side, and two lights shine inside the Hi-Lite for a high-key effect. **Top right**—Dog profiles are a wonderful way to showcase a breed. **Bottom left**—One of the many joys of doing this fund-raiser is that I am able to photograph so many breeds. Some breeds I've never seen before come through our doors for this event. **Facing page**—The three-legged friend became the poster child for Paws . . . for a Cause the year after we shot this image. He was an amazing dog and it was so great to be able to put his picture on all of our marketing materials.

great time of year, as things are a bit slower at the studio after the holidays, and we don't put on a big Valentine's Day event like many studios. We schedule several days of shooting where people bring in their dogs or cats for a fifteen-minute mini session. We used to hold this event at our studio, but the dog traffic in the hallway leading into the studio got a little crazy, so now we hold

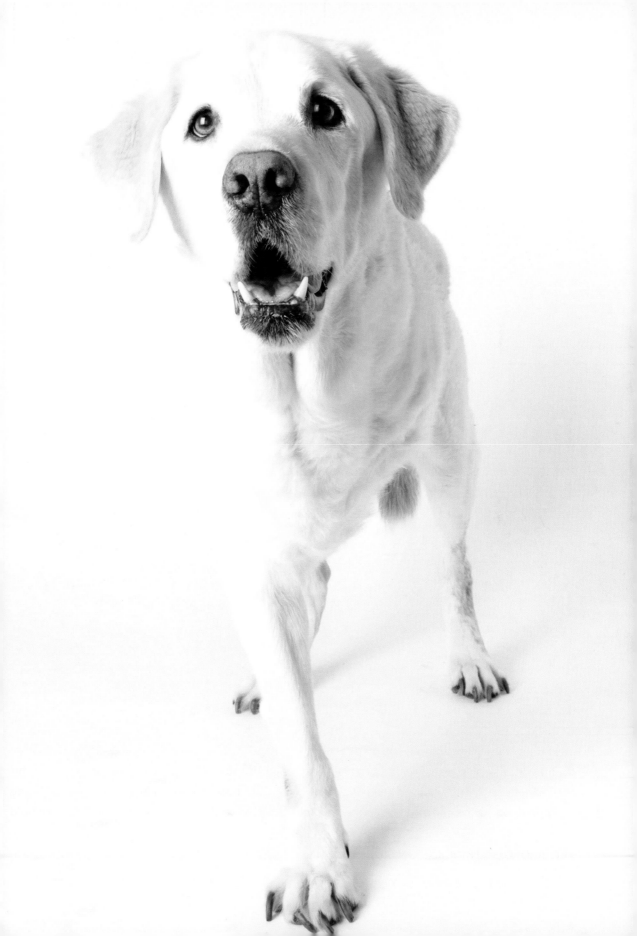

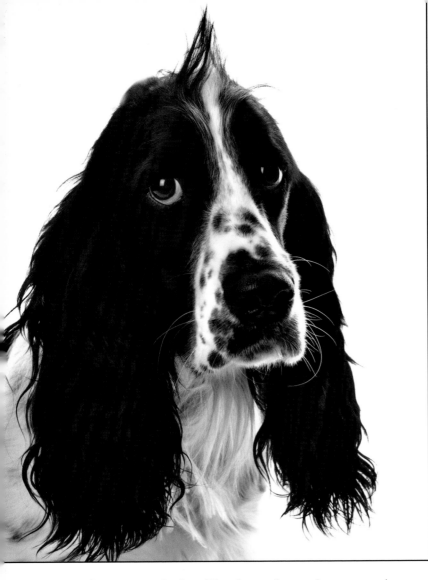

Left—We've seen it all—hairdos, outfits, and accessories. It's all about what the owner wants. **Facing page**—Dogs that are nervous (and many are, due to the number of smells in the studio during this fund-raiser) do well when held by their owners. I like having the neck in the shot to show the closeness.

it at the Humane Society. They have a large education room that can be blocked off, and animal owners can wait outside with companions until their session time.

We ask for a donation with Paws . . . for a Cause on the day of the session. At the time of this writing, we had participants donate $50 for a fifteen-minute session and a 5x7-inch print.

During this mini session, there are three people directing the animal: me, a Humane Society volunteer, and the dog owner. I've usually got the volunteer behind and above me with a squeaky toy and the owner is off to one side telling the dog to sit or lay down. I'm always thorough in explaining which areas are good places to stand. The dog owner and volunteer need to be aware of the lights and reflector so that they don't stand in front of them.

Many dogs who participate in this event do not respond to commands. Sometimes they even run all over the room, sniffing wildly. With dogs like these, we take the "coax-them-onto-the-backdrop-with-a-treat-snap-a-couple-let-them-run" approach. Holding down a dog who does

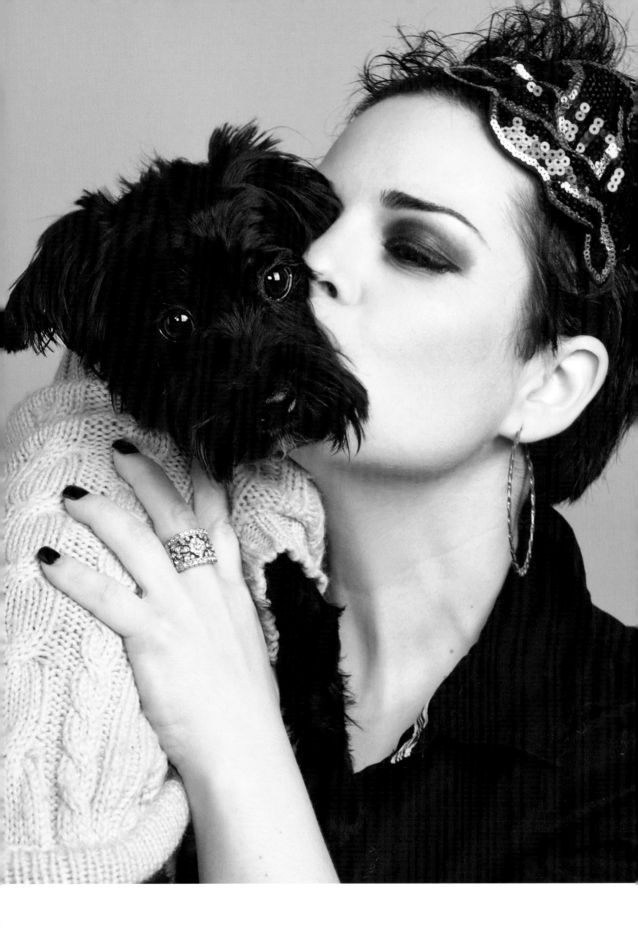

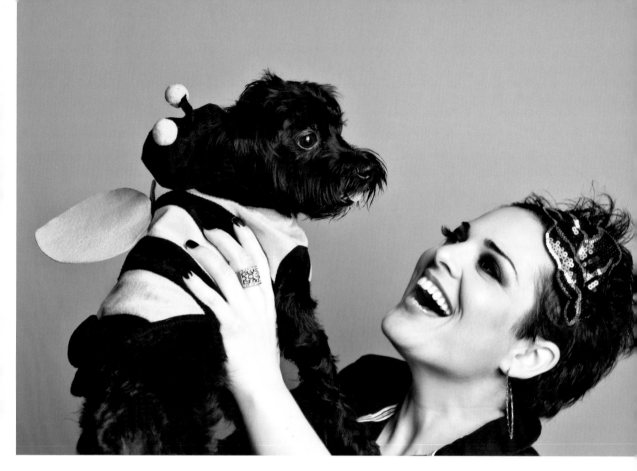

Facing page—I always ask the owners ahead of time whether they want to be in any of the images. Schepp's mom came ready for action. **Above**—The smiles on the owners' faces are the best part of photographing the owners and dogs together—especially when there's a bee costume involved!

not want to be on the backdrop is never a good idea. They look stressed and agitated and the general mood of the mini session is affected. It's best to just let untrained dogs "do their thing" and capture what you can. Like I said before, sometimes "doing their thing" involves defiling my backdrop paper and I have to do an impromptu cleanup! In this situation, the owner is usually mortified, and I am quick to tell them that it happens all the time and not to worry about it at all (if it hasn't happened in eons, they don't need to know that).

If I am working with a small dog and they are having trouble sitting in one spot, I will frequently have the owner place their back to the camera, pick up the dog, and hold him on the top of the shoulder facing the camera. This is a great way to get a nice facial shot of an active dog.

When we sign up dog owners for this event, I encourage them to come dressed to be in the images with their pet. I suggest monochromatic clothing and jeans, and I ask them to be mindful

not to wear colors that blend in with their dog's coat (black dog/black shirt is not a good look). This is such a special opportunity to capture the relationship between a pet and its owner. Some of my favorite images are of people loving on their dogs. You can see how special the bond is in these images, and the owners are often pleasantly surprised by how much they like the way they look. I think it's because they look happy and content. They're not focusing on wrinkles, forced smiles, or a double chin—"flaws" that can take center stage when they inspect their solo portraits.

During each of these sessions, I photograph the dogs with a specific product in mind. In the special collections that we offer for Paws . . . for

Top—Singing or baying dogs are a lot of fun, and I like to use these images in a series to show personality. **Bottom**—Small dogs can be placed inside of a variety of props. The trick is getting them to stay in place.

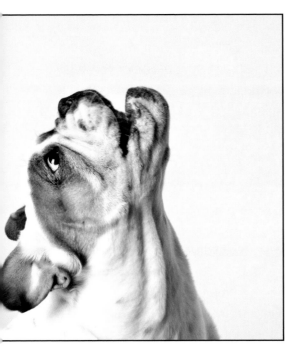

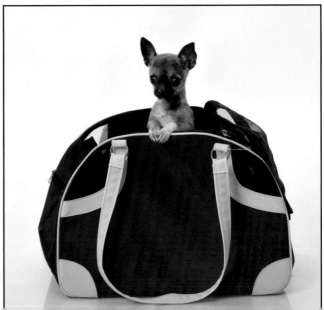

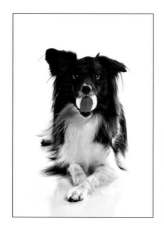

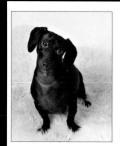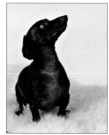

A series of story-telling images makes for a great art piece for your most discerning clients.

> I try to get them to give me the poses the owner knows and loves in succession.

a Cause, we include a framed piece called a "storyboard" that includes three "storytelling" images. When I work with these dogs, I try to get them to give me the poses the owner knows and loves in succession so that they can be matted in the storyboard frame.

RABBITS AND GUINEA PIGS AND CATS, OH MY!

Paws . . . for a Cause is not limited just to our dog friends. We let everyone know that we are ready for whatever animal they'd like to bring in, as long as our safety isn't in jeopardy. My personal favorite was Pickle, the costume-wearing guinea pig. He belonged to an employee of the Humane Society, and I took extra time to work with him and his wardrobe. I've never laughed so hard

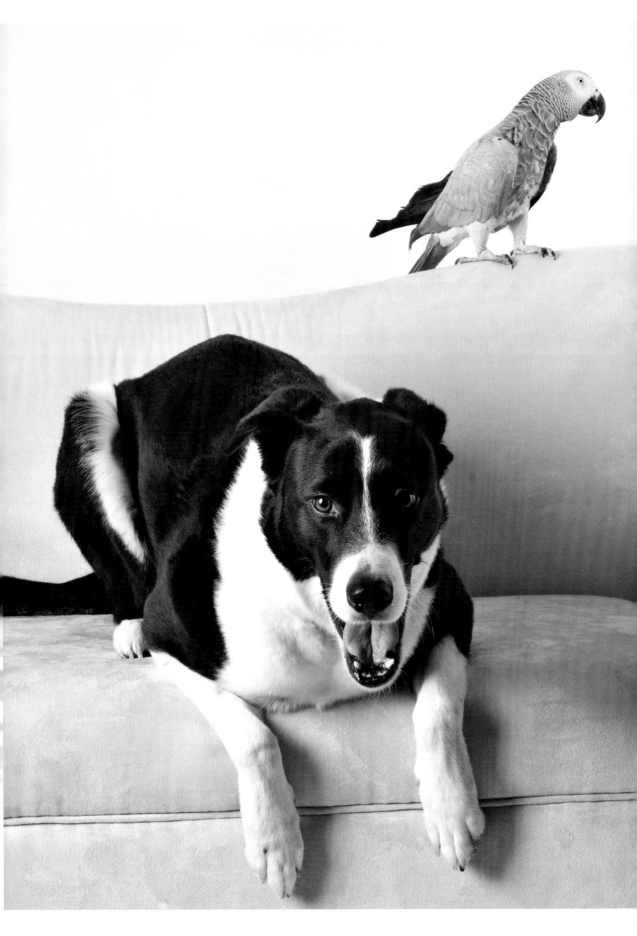

Facing page—These two spend a lot of time together hanging out at home, so this pairing came naturally. I used a couch to give the little bird more height. **Top right**—Pickle, my favorite non-dog to ever grace my backdrop, came with a complete wardrobe. **Bottom right**—Pickle was surprisingly well-behaved, and he stayed in one place. I love these shots!

Putting a feline friend over the owner's shoulder is a great way to go, as is putting them up high on a chair.

during a session, and I vowed to add more guinea pigs to my repertoire!

Cats are a bit difficult to work with, as they don't listen to commands. As I mentioned before, putting a feline friend over the owner's shoulder is a great way to go, as is putting them up high on a chair. Dangling some string or a cat toy above their heads works sometimes, but frequently it will just result in a back-and-forth motion of having them run off the backdrop and the owner

Top left and right—We've begun to show last year's winner on the current year's marketing materials. This creates a buzz for the winner's owner, and the materials are more likely to be shared with others. **Bottom**—LBI branding is everywhere you look during this fund-raiser. **Facing page**—Bix, a two-time calendar contest winner for Paws . . . for a Cause is extremely poseable. He will pretty much do anything but speak English.

placing them down again. Rabbits are pretty similar in this regard, and we just go with it.

We had a session with another Humane Society employee who brought in her dog and bird. Through some creative cropping, these were some of my favorite shots from that year's images. I'm not a bird expert by any stretch of the imagination, so I just focused on the dog and the owner worked to help get the bird where it needed to be. I think people bringing in exotic animals just appreciate the fact that you're willing to give it a shot—literally! Personally, I like to change it up sometimes, and if all it takes to get me excited is an interesting combination of animals, I'm game.

EVENT GOODIE BAGS

We provide bags with our studio logo and brand colors for the fund-raiser participants. In the weeks leading up to the event, Humane Society

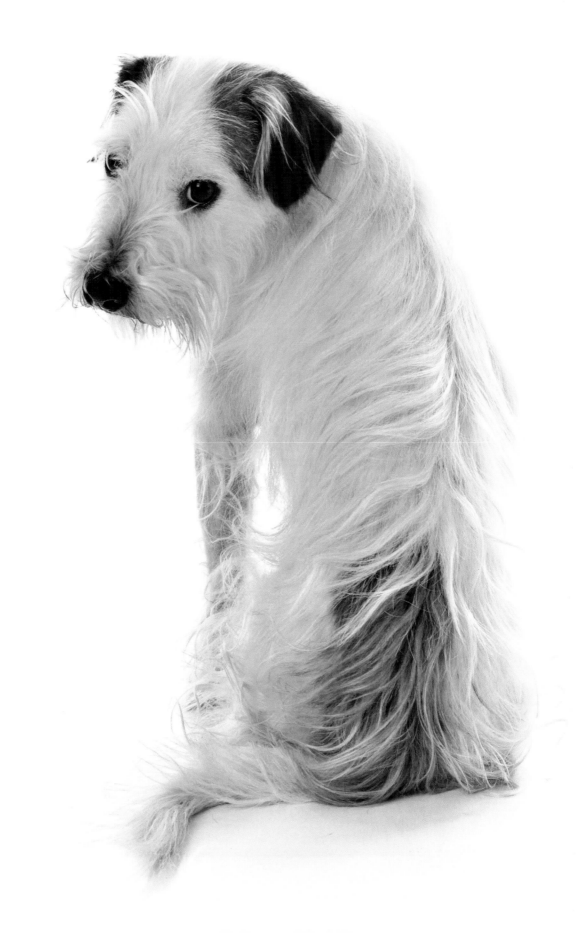

employees and I contact all the dog-centered businesses in our area, asking if they'd like to include something. Our goodie bags have really grown to be something special over the years. Valuable coupons, dog treats, and chew toys are just some of the items that are gifted to the dog owners. I think it's a nice thing for them to receive when they're making a donation to a charity.

The goodie bag is a good place for our studio marketing materials that showcase our Dog-u-mentary sessions. Many of these dog owners are our perfect client, and we want them to know that we offer something special in the way of dog portraiture. I also place some Day in the Life albums on the table for Paws . . . for a Cause participants to look at while they're waiting.

I've met some of my best clients through Paws . . . for a Cause. Each year I send them a personal invitation a month prior to the event so that they can acquire a desirable session time. The coveted Saturday sessions always go first. These clients need to know that we give them preferential treatment because we appreciate their loyalty.

THE CALENDAR CONTEST

The Southwest Washington Humane Society puts together what I think is a brilliant fund-raiser in the form of a calendar contest. Anyone can enter an image of their pet for a fee, but the participants of Paws . . . for a Cause get a reduced rate to enter. Not only that, they get to choose from the professional images that were taken by our studio and increase their odds of getting their pet in the calendar.

A few months after our event is over, the Humane Society creates a web site where all the images entered into the calendar contest can be viewed. It is there that a vote can be cast for an animal to get into the calendar. Each vote costs the voter $1.00, but this quickly adds up and the Humane Society can make close to $30,000.

The calendars are then printed and sold at the Humane Society as well as at their annual auction in the fall. I help with the design of the calendar and also cosponsor it with our own monetary donation to have it printed. It always turns out beautifully, and we are so proud to be a part of the process!

PRESS RELEASES

Whenever you do a fund-raising event or work with a charitable organization, it is a great idea to send a press release to your local paper about it. Sometimes after receiving our release, newspapers have even sent reporters to cover the story the day of the event. It's great publicity for the charitable organization, and of course, for the studio. I frequently send images with my logo on them to the newspaper along with the press release so that they can include them, even if they can't capture the event themselves. Small local papers count in the quest for media coverage, I might add. Our local small paper goes out to our entire community, and I'm always surprised by how many people will tell me that they saw an article about our studio. People want to know what their neighbors are up to! It's a great way to get the word out.

EVENT ADVERTISING

We create a custom, one-of-a-kind poster each year for Paws . . . for a Cause, and the poster itself has proven to create quite a buzz around town. Participants from the previous year always ask if their dog made it onto the poster.

Choosing our favorite images for the poster is one of my favorite parts of doing this fund-raiser. I also love e-mailing the dog owner to let them know their dog is part of our advertising campaign. It's surprising how exciting this is for some people, but we love their enthusiasm.

We also have a local print shop produce 4x6-inch cards with the event info and an eye-catching image on one side under our logo. These cards are delivered to every vet clinic, dog boutique, and dog daycare in a twenty-five-mile radius. We also blog about it each week leading up to the event and post on our own Facebook page as well as the Humane Society's page. Any way we can get the buzz going about this annual event, we will do it. It's our "big hurrah," so we want as many people to participate as possible.

POST-EVENT BUZZ

I find that building the readership on our studio blog is a great way to create client loyalty. I tell the Paws . . . for a Cause participants to check out our blog weekly after the event because we will be featuring many of the dogs captured during this fund-raiser. People who consider their dogs to be their kids get very excited about seeing their pet on our blog—achieving a bit of a "rock star" status. We love that about our clients, and we want to honor it by featuring their animal.

As I mentioned in chapter 3, we send out a studio newsletter every month featuring a Dog of the Month. This is a perfect opportunity to feature two special dogs in the two monthly newsletters after the event. I usually pick clients whose dogs come every year. The dog's owner obviously supports the Humane Society and our studio by such active participation, and I like to reward that with some newsletter features of their pet.

It's smart to feature images of dogs with their owners in your newsletters. The owners are more likely to share the newsletter with their friends.

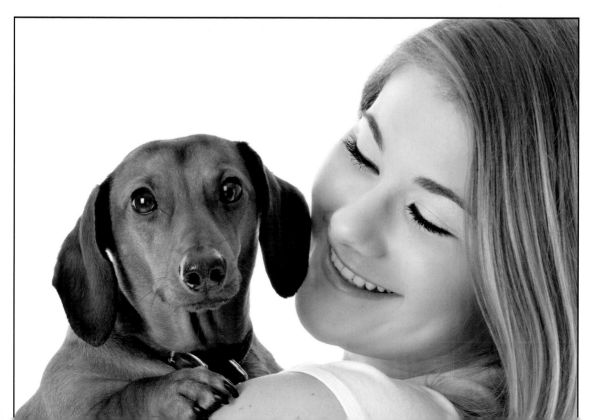

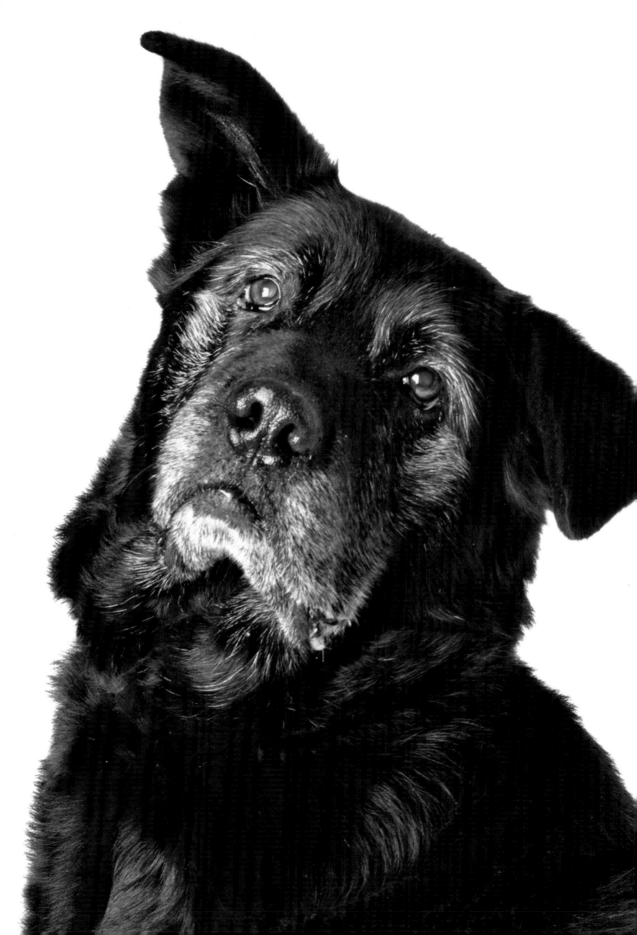

9. Ensuring Repeat Business

Dogs' lives are really too short. Their only flaw, really.—Agnes Sligh Turnbull

GIFTS FOR YOUR CLIENT

When going to a client's residence for a consultation, bringing a chew toy with your logo can make a big impact. Not only is it seen as thoughtful to bring a gift for your client's pooch, but it is something that (hopefully) will remain in the toy stash for a while, reminding your client of the great portrait experience they had with you.

There are many companies that can create custom dog products with your logo on them. There is usually a setup fee and then a price per item, which may be reduced when ordering in bulk. Do a search online for "dog products with my logo" or "promotional products for my business." There are tons of companies on the Internet that specialize in this. Do some price shopping first, because the price range from one site to another varies quite a bit.

I opted to go the chew toy route, but there are many options: collapsible water bowls, pet trash bag containers, leashes, and Frisbees. I think it depends on the lifestyle of your client.

Facing page—Older dogs tend to be calm and collected subjects. The gray on an aging dog's face makes for a very distinguished portrait.

If you photograph dogs primarily outside with them running and having a great time, a tennis ball or Frisbee would be a great item to bring as a gift at session time. If you primarily work with small dogs who live in the city, perhaps a fancy leash or a dog pillow would make a better gift.

Dog-inspired products that feature your logo can also be given to the businesses where you have displays, as they can be placed in goodie bags at holiday time. Keeping that logo in front of your target market is essential; it will help recall your business name when they're ready for dog portraits. "I just see your stuff everywhere" is the best phrase a photographer can hear; it means you are doing a bang-up job of marketing your studio and becoming the dominant niche studio presence in your area.

BIRTHDAY WISHES

Believe it or not, many dog owners celebrate their dogs' birthdays (you may be one of those people!). I've had a client who rented out a dog daycare to host a party for the many canine friends of her Pomeranian. This, my dear dog photographer friends, is *our* client. Jotting down dogs' birthdays as they come in to be photographed can help you with your marketing.

 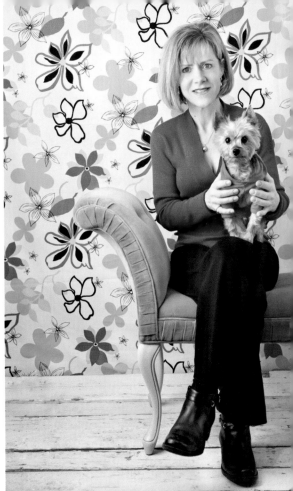

Left—Ozzie was a wonderful little personality. **Right**—Kate told me what colors she loved and I made sure to style the session accordingly.

I like to send out a birthday card with an image of the dog from a past session and a studio gift certificate for $50 for the owner. Not only are they impressed that you remembered their dog's big day, but they most likely will want to come in for some more portrait fun.

Side note: if you are a person who finds it absolutely ridiculous to have a birthday party for a pet, perhaps the dog portrait business is not for you. Folks who treat their animals like their children are the people you most want to call

your studio. They won't find it silly to hang large prints of their dogs on walls or purchase a custom album of their dog for the coffee table. All of these things, of course, mean a higher yield when you go into the ordering/viewing session. These "dog fanatics" will be your bread and butter, and doing things like remembering their dogs' birthdays will endear you to your clients. They love it when others "get" the this-dog-is-my-kid thing. I think people feel it's nice to be understood.

BEREAVEMENT

On the other side of the spectrum, when a client loses a beloved animal, it is equally important to send your sympathies and condolences. We form very strong relationships with our clients and their dogs during the portrait-making experience. I think it's the "dog person" thing—we all seem to understand how important these pets are in our lives. I like to send an image from the dog's last session and a card from all of us at the studio to let them know we are thinking of them. We actually have given certificates to the vets where we display our images. The vet gives these certificates to clients with dogs who are near death's door as a gift from the vet hospital.

We frequently schedule emergency sessions for animals that are extremely ill or are going to be put to sleep. The owners want that one lasting image of their dog to cherish. These appointments are very hard for me, and there are times I even cry with the owner during the session, but I feel that it's extremely important to provide this for grieving dog owners. It is also something the client will remember and hold dear when it's time to get another dog and choose a portrait studio. We want to be their dog's photography studio for life.

Here's a story about what can happen when you become close to your clients and their dogs: I had a client named Kate who brought all three of her dogs to me several times over the course of three years for portraits. One of her dogs passed away and we were able to capture Ozzie at his

Top—This image was from Fauna's first session.
Bottom—This image was from the last session we did before Kate passed away.

best before he died. Kate and I ended up becoming good friends through this grieving time.

When Kate found out she had a quickly progressing form of the autoimmune disease ALS, my studio assistant (who also became close with Kate) and I went to visit her several times as her disease progressed. It wasn't clear what was going to happen to her Chihuahua, Fauna, upon Kate's death, but when I immediately told her that our family would love to adopt her, I believe she felt tremendous relief, knowing that this dog she loved so dearly was going to be well taken care of.

Fauna has bonded to our family, and for me, it's like having a little piece of Kate still with us. It is at times like this that I *know* that I chose the right niche of photography for my business. The bonds with these dogs and their owners have added a great deal to my personal life as well as my work life.

HOLIDAY GIFTS

It's always a hit when our holiday ornaments go out to our clients each December. We choose our favorite image of each dog we've photographed that year, place it in a 2x3-inch ornament frame, and send it to each client in festive packaging. It's about a $5.00 to $7.00 investment for each client, but it's so worth it. The thank-you messages we receive through e-mail and on our studio voicemail are so much fun to listen to. It really is the little things that matter when it comes to customer service.

For clients who have been really good to us over the year in order sales, we like to send a gift certificate to say thank you. I like to do this in increments big enough so they can receive a small framed print.

Our studio holiday card is also something we put a lot of thought into each year. It's become something of a "can we top last year's?" thing,

If I have two images that go together nicely, I will sometimes send two ornaments to clients who have invested a lot with our studios.

but it's always fun to get a great response from clients. We've actually had people call us to say they didn't receive one! Of course, we pop it in the mail as fast as we can. We're glad that the cards have made an impression.

Branding, branding, branding. Your message must be consistent throughout all of your materials.

Here we are, channeling the Brady Bunch.

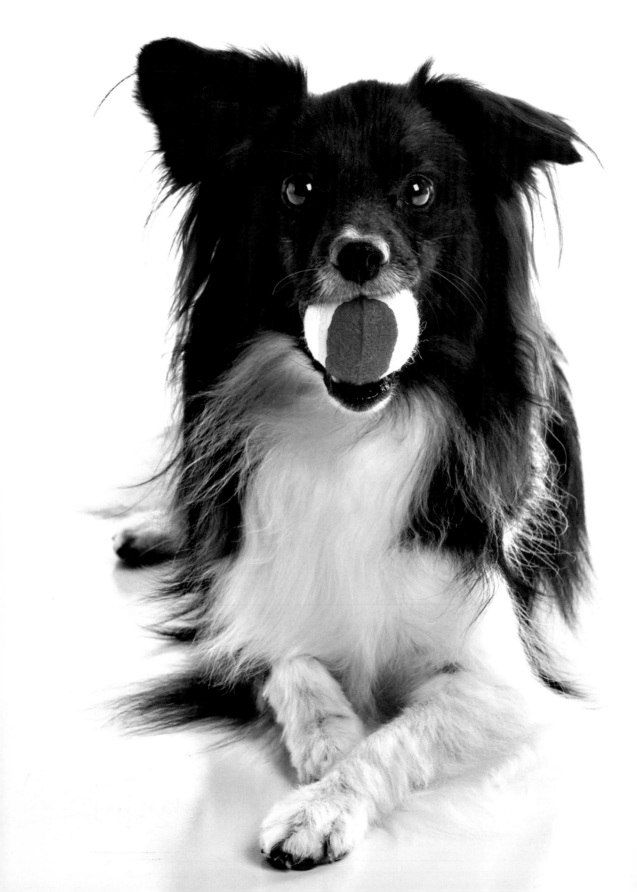

10. Stock Photography

If I could be half the person my dog is, I'd be twice the human I am.—Charles Yu

This is an area that I have not had a lot of experience with, but I have many photographer friends who make part of their living shooting stock. If your images become desirable to a company and they wish to create a contract with you to license these images, it is best to be armed with all of the information you will need to negotiate rates.

As far as dog photography goes, there are quite a few commercial uses for dog images. The best route to go is to join a stock agency online and upload your images to the site for potential buyers to view. It is crucial that you have a photo release on file for every creature (two feet or four feet) in the image. There are several stock agencies out there, as well as micro-stock agencies where imagery can be purchased for less than a dollar. It might seem silly to offer the rights to an image for pennies on the dollar with a micro-stock agency, but if thousands of people acquire an image for advertising, it can add up nicely. These stock agencies take a percentage of your sale. For example, Photostockplus.com takes 15 percent of a sale.

If you build up a huge library of images and are willing to upload them regularly, stock photography can be a welcome addition to your photography studio. I found that I was too busy to dive into this world. I might down the road when I'm taking fewer sessions, but for now, I'm as busy as I need to be. I already spend a great deal of time in front of my computer screen, and the thought of adding more postproduction time does not appeal to me. If the idea appeals to you, there are great seminars out there about stock photography, such those offered by Paul Henning, a photographer who has had quite a bit of success in stock photography.

LEGAL MATTERS

We have every client we work with sign a model release at the ordering appointment. Our release states that we are able to use the images for advertising and display. This can eliminate any future problems with clients seeing images that are used without their permission. For this book, in fact, we had a special release for each owner to sign. With pets, I use the same rules as with humans. I must have written consent before I use the image for advertising, publishing, or any other marketing that I do.

Facing page—A dog is always happy to see me at the studio. I just give the pooch a ball or treat and all is well!

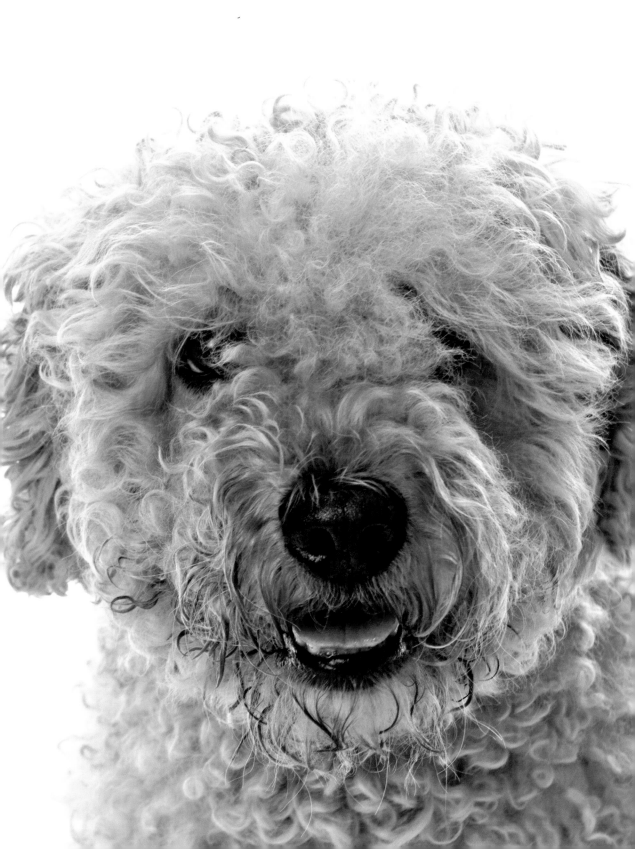

Conclusion

Once you have had a wonderful dog, a life without one is a life diminished. —*Dean Koontz*

As I've written this book, it has surprised me how much goes into serving one particular market in the industry of photography. I do believe it's "in the details" and that focusing on one area can greatly increase the odds of financial success. Sometimes working with all types of subjects in the portrait world can spread the marketing plan so thin, that it doesn't reach the market you desire at all in the end. By concentrating on one portrait niche, you can saturate the community and Internet with your studio presence. It is so much easier to reach one market rather than multiple markets.

Being a lover of dogs in my everyday life, I have found that working with them makes a day in the studio so much more enjoyable. Dogs love being in the studio, never ask you to get rid of their wrinkles or fat rolls in Photoshop, and are almost always happy to see you. Dog owners and

I have common ground in that we both adore spending time with these canine friends. This bond can prove to be very helpful in building a relationship with clients. We have had some very special people over the years trust us to capture this extraordinary relationship.

Choosing a market of dog owners doesn't have to happen overnight. If your studio relies heavily on family and high-school senior portraits, by all means, ease on into this territory a little at a time. That's the beautiful thing about heading in one direction while still moving ahead in the spot you've always been. A little marketing in the dog market can go a long way. I did not intend on running a dog portrait studio, but I found through baby steps of moving toward this group, I loved it enough to capture them exclusively. It is a privilege!

Facing page—Dog photography is rewarding. Delve into your artistic options and finesse your business plan, then cultivate your relationships with your clients for the best-possible creative and financial returns.

Resources

GREAT COFFEE-TABLE BOOKS

101 Salivations: For the Love of Dogs by Rachael Hale (Bullfinch, 2003)

A Breed Apart: A Celebration of the New American Mutt by Amanda Jones (Clarkson Potter, 2007)

Dachshunds Short and Long by Amanda Jones (Berkley Trade, 2009)

Designer Dogs: Portraits and Profiles of Popular New Crossbreeds by Caroline Coile and Anna Kuperberg (Gold Street Press, 2007)

Dogs by Lewis Blackwell and Tim Flach (Abrams, 2010)

Greyhounds Big and Small: Iggies and Greyts by Amanda Jones (Berkley Trade, 2009)

If Only You Knew How Much I Smell You: True Portraits of Dogs by Valerie Shaff and Roy Blount (Bulfinch, 1998)

Shelter Dogs by Traer Scott (Merrell Holberton, 2009)

Snog: A Puppy's Guide to Love by Rachael Hale (Little, Brown and Company, 2007)

DOG PHOTOGRAPHY TECHNIQUE BOOKS

Professional Techniques for Pet and Animal Photography by Debrah H. Muska (Amherst Media, 2003)

Pet Photography NOW! A Fresh Approach to Photographing Animal Companions by Paul G. Walker (Lark Books, 2008)

Creative Canine Photography by Larry Allan (Allworth Press, 2004)

How to Photograph Pets by Nick Ridley (Guild of Master Craftsmen Publications, 2002)

OTHER HELPFUL BOOKS

The Photographer's Guide to Making Money: 150 Ideas for Cutting Costs and Boosting Profits by Karen Dórame (Amherst Media, 2009)

The Business of Photography by Damon Tucci and Rosena Usmani (Amherst Media, 2010)

CHARITABLE ORGANIZATIONS FOR ANIMALS

The Humane Society of the United States
www.humanesociety.org

Best Friends Animal Society
www.bestfriends.org

Adopt-a-Pet
www.adoptapet.com/dog-shelters

International Animal Rescue
www.internationalanimalrescue.org

TRAINING WORKSHOPS

Dog Training USA
www.dog-training-usa.com

PetSmart
training.petsmart.com

MY FAVORITE PHOTO AND PACKAGING RESOURCES

White House Custom Color Lab
www.whcc.com

Simply Canvas
www.simplycolorlab.com

Pro Select Software
www.timeexposure.com

NPD Box Company
www.npdbox.com

Bags and Bows
www.bagsandbowsonline.com

Index

OTHER BOOKS FROM

Amherst Media®

THE PHOTOGRAPHER'S GUIDE TO MAKING MONEY
150 ideas for Cutting Costs and Boosting Profits

Karen Dórame provides surprising tips for cutting costs and boosting profits. *34.95 list, 8.5x11, 128p, 200 color images, index, order no. 1887.*

TUCCI AND USMANI'S
The Business of Photography

Take your business from flat to fantastic using the foundational business and marketing strategies detailed in this book. *$34.95 list, 8.5x11, 128p, 180 color images, index, order no. 1919.*

On-Camera Flash TECHNIQUES FOR DIGITAL WEDDING AND PORTRAIT PHOTOGRAPHY

Neil van Niekerk teaches you how to use on-camera flash to create flattering portrait lighting anywhere. *$34.95 list, 8.5x11, 128p, 190 color images, index, order no. 1888.*

Lighting Techniques
FOR PHOTOGRAPHING MODEL PORTFOLIOS

Billy Pegram analyzes real-life sessions, showing you how to make the right decisions each step of the way. *$34.95 list, 8.5x11, 128p, 150 color images, index, order no. 1889.*

Commercial Photography Handbook

Kirk Tuck shows you how to identify, market to, and satisfy your target markets—and maximize profits. *$34.95 list, 8.5x11, 128p, 110 color images, index, order no. 1890.*

Creative Wedding Album Design WITH ADOBE® PHOTOSHOP®

Mark Chen teaches you how to master the skills you need to design stunning and unique wedding albums. *$34.95 list, 8.5x11, 128p, 225 color images, index, order no. 1891.*

CHRISTOPHER GREY'S
Studio Lighting Techniques for Photography

With these strategies and some practice, you'll approach your sessions with confidence! *$34.95 list, 8.5x11, 128p, 320 color images, index, order no. 1892.*

The Beginner's Guide to Photographing Nudes

Peter Bilous explains how to find models, plan and execute a successful session, and get your images seen. *$34.95 list, 8.5x11, 128p, 200 color/ b&w images, index, order no. 1893.*

JEFF SMITH'S **Senior Portrait Photography Handbook**

Improve your images and profitability through better design, market analysis, and business practices. *$34.95 list, 8.5x11, 128p, 170 color images, index, order no. 1896.*

Photographic Lighting Equipment

Kirk Tuck teaches you how to build the best lighting arsenal for your specific needs. *$34.95 list, 8.5x11, 128p, 350 color images, 20 diagrams, index, order no. 1914.*

Advanced Wedding Photojournalism

Tracy Dorr shows you how to tune in to the day's events and participants so you can capture beautiful, emotional images. *$34.95 list, 8.5x11, 128p, 200 color images, index, order no. 1915.*

Corrective Lighting, Posing & Retouching FOR DIGITAL PORTRAIT PHOTOGRAPHERS, 3RD ED.

Jeff Smith shows you how to address and resolve your subject's perceived flaws. *$34.95 list, 8.5x11, 128p, 180 color images, index, order no. 1916.*

CHRISTOPHER GREY'S
Advanced Lighting Techniques

Learn how to create stylized lighting effects that other studios can't touch with this witty, informative guide. *$34.95 list, 8.5x11, 128p, 200 color images, 26 diagrams, index, order no. 1920.*

THE DIGITAL PHOTOGRAPHER'S GUIDE TO
Light Modifiers SCULPTING WITH LIGHT™

Allison Earnest shows you how to use an array of light modifiers to enhance your studio and location images. *$34.95 list, 8.5x11, 128p, 190 color images, 30 diagrams, index, order no. 1921.*

Multiple Flash Photography

Rod and Robin Deutschmann show you how to use two, three, and four off-camera flash units and modifiers to create artistic images. *$34.95 list, 8.5x11, 128p, 180 color images, 30 diagrams, index, order no. 1923.*

CHRISTOPHER GREY'S
Lighting Techniques
FOR BEAUTY AND GLAMOUR PHOTOGRAPHY

Use twenty-six setups to create elegant and edgy lighting. *$34.95 list, 8.5x11, 128p, 170 color images, 30 diagrams, index, order no. 1924.*

BRETT FLORENS' Guide to
Photographing Weddings

Learn the artistic and business strategies Florens uses to remain at the top of his field. *$34.95 list, 8.5x11, 128p, 250 color images, index, order no. 1926.*

500 Poses for Photographing Brides

Michelle Perkins showcases an array of head-and-shoulders, three-quarter, full-length, and seated and standing poses. *$34.95 list, 8.5x11, 128p, 500 color images, index, order no. 1909.*

Understanding and Controlling Strobe Lighting

John Siskin shows you how to use and modify a single strobe, balance lights, perfect exposure, and more. *$34.95 list, 8.5x11, 128p, 150 color images, 20 diagrams, index, order no. 1927.*

JEFF SMITH'S
Studio Flash Photography

This common-sense approach to strobe lighting shows photographers how to tailor their setups to each individual subject. *$34.95 list, 8.5x11, 128p, 150 color images, index, order no. 1928.*

Just One Flash

Rod and Robin Deutschmann show you how to get back to the basics and create striking photos with just one flash. *$34.95 list, 8.5x11, 128p, 180 color images, 30 diagrams, index, order no. 1929.*

WES KRONINGER'S
Lighting Design Techniques
FOR DIGITAL PHOTOGRAPHERS

Create setups that blur the lines between fashion, editorial, and classic portraits. *$34.95 list, 8.5x11, 128p, 80 color images, 60 diagrams, index, order no. 1930.*

DOUG BOX'S
Flash Photography

Doug Box helps you master the use of flash to create perfect portrait, wedding, and event shots anywhere. *$34.95 list, 8.5x11, 128p, 345 color images, index, order no. 1931.*

500 Poses for Photographing Men

Michelle Perkins showcases an array of head-and-shoulders, three-quarter, full-length, and seated and standing poses. *$34.95 list, 8.5x11, 128p, 500 color images, order no. 1934.*

Off-Camera Flash
TECHNIQUES FOR DIGITAL PHOTOGRAPHERS

Neil van Niekerk shows you how to set your camera, choose the right settings, and position your flash for exceptional results. *$34.95 list, 8.5x11, 128p, 235 color images, index, order no. 1935.*

Wedding Photojournalism
THE BUSINESS OF AESTHETICS

Paul D. Van Hoy II shows you how to create strong images, implement smart business and marketing practices, and more. *$34.95 list, 8.5x11, 128p, 230 color images, index, order no. 1939.*